HOFMEKLER'S PEOPLE

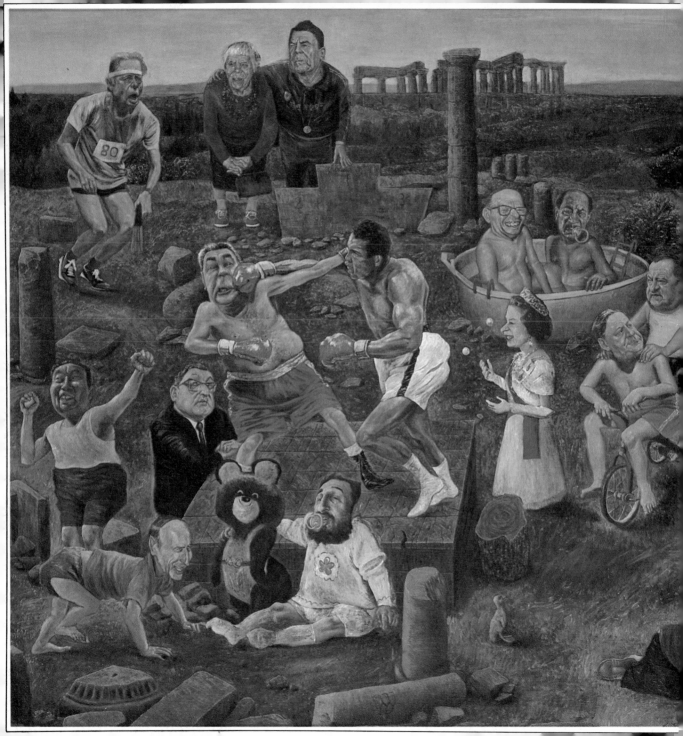

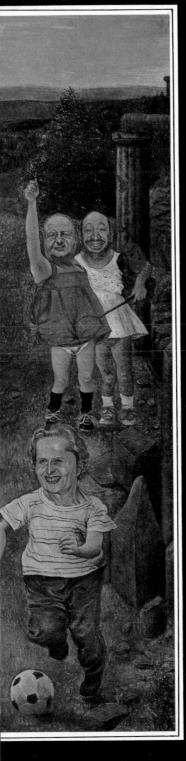

HOFMEKLER'S PEOPLE

Ori Hofmekler

An Owl Book

Holt, Rinehart and Winston / New York

Contents

Illustrations copyright © 1982 by Ori Hofmekler
Text copyright © Europa Publications Limited 1981,
1982

Biographies reprinted from *The International Who's Who
1981-82* (Europa Publications Limited, London)

Published in the United States by Holt, Rinehart and
Winston, 383 Madison Avenue, New York, New York
10017.

Library of Congress Catalog Card Number 82-83651

First American Edition

Hofmekler's People was conceived and edited by
Nicholson Books
10 Price Street
Toronto, Ontario, Canada
M4W 1Z4

Design: Maher & Murtagh

Printed in Spain by Printer Industria Graphica S.A.

D.L.B. 40844-1982

ACKNOWLEDGEMENTS
Patrick Crean, Bob Crew, Laurie Freedman, Michael
Hanlon, Susan Harrington, Itzhak Lichtenfeld, Judy
MacGregor Smith, David Miller, Robert Ramsay, and
special thanks to Judy Tater.

ISBN: 0-03-063371-0

Foreword

In the 17th century, the Popes were depicted on church walls generally on the condition that they be prominently placed beside the Holy Virgin Mother.

Today, in a more secular world, a head of state may stare out at you from the glossy pages of a woman's magazine generally alongside a comely portrait of the latest leggy super-model of the day. Indeed, politicians and movie starlets have replaced bishops and madonnas.

Leonardo and Goya did portraits of the important people of the past, and these figures now belong to history. I work with today's big shots. Perhaps history will dignify them as well...

When I was small, I was told that there are two kinds of people in the world: the important and the very important. While I humbly admit that I may fall into the first category, I also declare that those of the second category follow me everywhere. From the pages of newspapers, from the TV screen, they scream for my attention. On bank notes, on postcards and even on greeting cards, they vie with each other to make themselves known.

That is why I feel portraying "important people" reflects the world in which we live, and that is why I felt the need to invite some of them into my studio.

I started this crazy notion with a friend—Itzhak Lichtenfeld—a psychologist by profession. Together we opened a studio and developed these ideas. The process of working on a V.I.P. is usually unpleasant, and the results—unexpected. The chosen one is laid out on the work table alongside

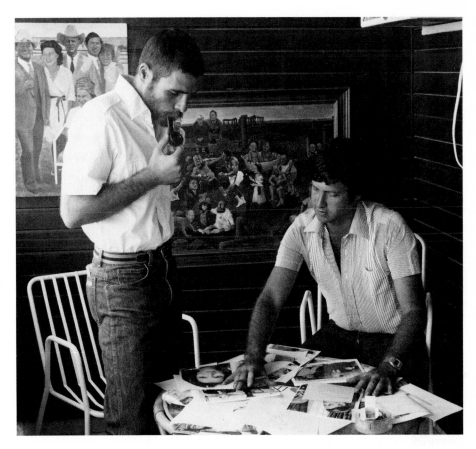

a lot of material lifted from archives: photographs, articles, etc. And the raw data, often greasy and tattered, undergoes dozens of sketches. Then I do some model shootings, continuing with more sketching before the final portrait emerges, scrubbed and imbued with all the facets of the person's public image.

I use tempora technique for the artwork, and require varying amounts of time for each character. Mostly though, it takes me two or three weeks of intense treatment to produce an important person sufficiently renovated to leave the studio on his or her own.

This, therefore, is a collection of my political figures. It isn't necessarily true that the chosen ones are the most important ones.

And it isn't necessarily true that the important ones are important at all.

Devoted to Daniel Hofmekler

Ori Hofmekler.
Tel Aviv, November, 1982.

Introduction

Hofmekler's People is a very important book.

This is the work, collected here for the first time, of a rare talent, a talent that combines both a high sense of art with a truly extraordinary humour. The portraits which follow strike a deep popular chord which inevitably evokes response. Indeed, whatever your political views may be, you cannot fail to be affected by the genius of Hofmekler.

With incisive, biting wit and a pen dipped in acid, Ori Hofmekler's brilliantly original satire pokes a very funny, yet often sobering finger at many of our world leaders. From a rogue elephant Big Daddy Amin to a Churchillesque Margaret Thatcher, from Carter's "whupping" of Teddy Kennedy to Pope John Paul as an "easy rider", this outstanding young Israeli artist has captured unexpected yet disturbingly accurate characteristics of several of the power-brokers of our world.

And counterpointing Hofmekler's satirical portraits, the characters speak for themselves, after the fact, in a selection of revealing and ironic quotations from their own records.

Born in March 1952, in Tel Aviv, Israel, Ori Hofmekler composed his first figurative drawings at the age of five. His subjects then were mostly animals—crocodiles, tigers and lions. Later, in High School, he started sculpting, and began doing portraits of people around him, especially his teachers. He claims he was lucky not to have been caught with this early satire.

Hofmekler's academic studies forced him to question the place of the artist in society today. His work during this period was mostly a search for a stereotypic point of view. Philosophic and psychological theories and ideas influenced his way of looking for new approaches to the most basic and primitive nature of mankind.

Upon completing his courses at the Bezalel Academy of Art, and graduating from the Hebrew University in Jerusalem, Hofmekler, like most young artists, started to work with galleries.

His drawings and engravings began to sell in Tel Aviv and London, England. And in an attempt to relate the real problems of the banal everyday things and events reported in the daily press, he began drawing political portraits. It quickly became apparent to him however that these could not be readily exhibited in galleries, so he started to search for a vehicle from which to display his work. In this way, he became involved in magazines and the print media, doing mainly political commissions. Hofmekler then opened a studio with a business partner, Itzhak Lichtenfeld. Working as a team saves him a lot of time and allows him to concentrate on his paintings.

Now working full-time from his studio in Tel Aviv, Ori Hofmekler has created a literal whirlwind of attention for his work. Possibly the most controversial was the time *L'Express* magazine in France ran a Hofmekler picture on its front cover in May, 1981, showing the incumbent president Giscard d'Estaing in defeat—published *before* the election. The original plan had been for Hofmekler to draw *both* d'Estaing and Mitterand in defeat. Whoever lost in the upcoming election was to grace the cover of *L'Express*. But because the editors of the magazine decided to jump the gun and second-guess the outcome, although as it turned out their guess was correct, an uproar

ensued, and senior editors were fired by the owner, a supporter of d'Estaing. Hofmekler's portrait of Mitterand in defeat is reproduced here for the first time as the "other" portrait France did not see at the time because Mitterand of course won.

Hofmekler enjoys long-term commissions from such magazines as *Penthouse* (U.S.A. and Germany), and the support of numerous patrons of the arts for an exhibition to be shown throughout Europe and North America.

Ori Hofmekler, who lives with his wife Ilana and their 4-year-old son Daniel, is without doubt a rapidly rising young talent of world calibre. He is currently working on his second book, a satirical revue of characters in the world of "show business".

And as Hofmekler readily admits, there will always be some very important people who will drive him crazy…

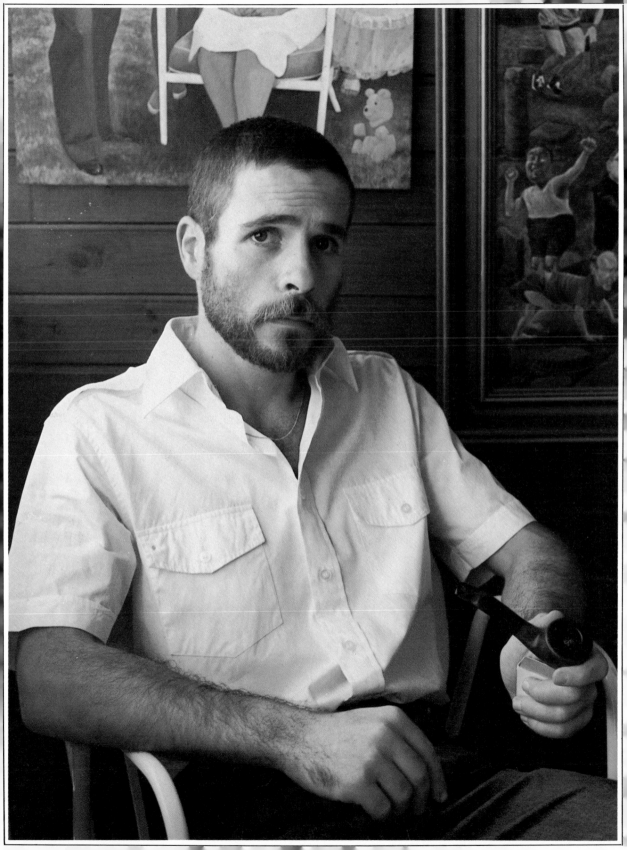

Reagan

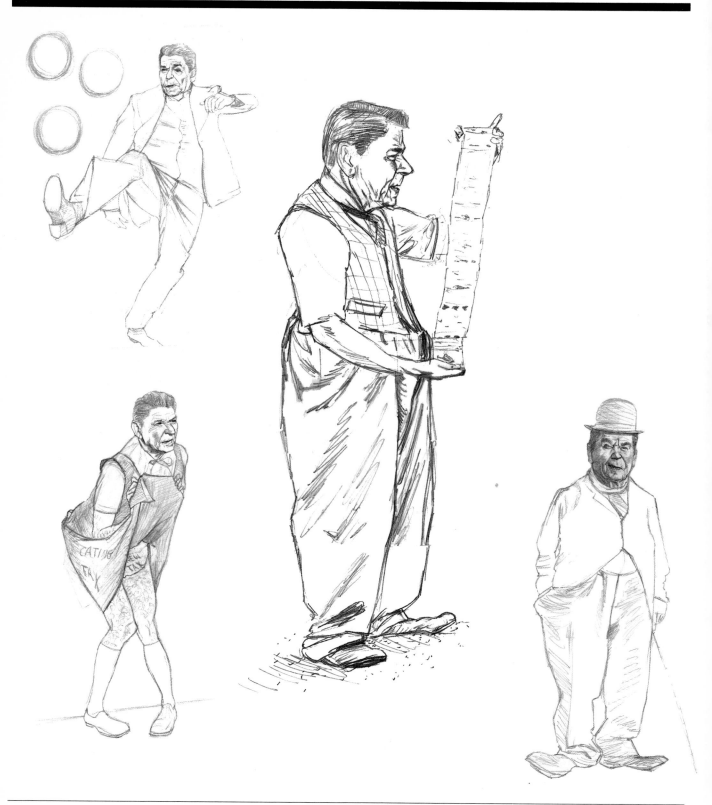

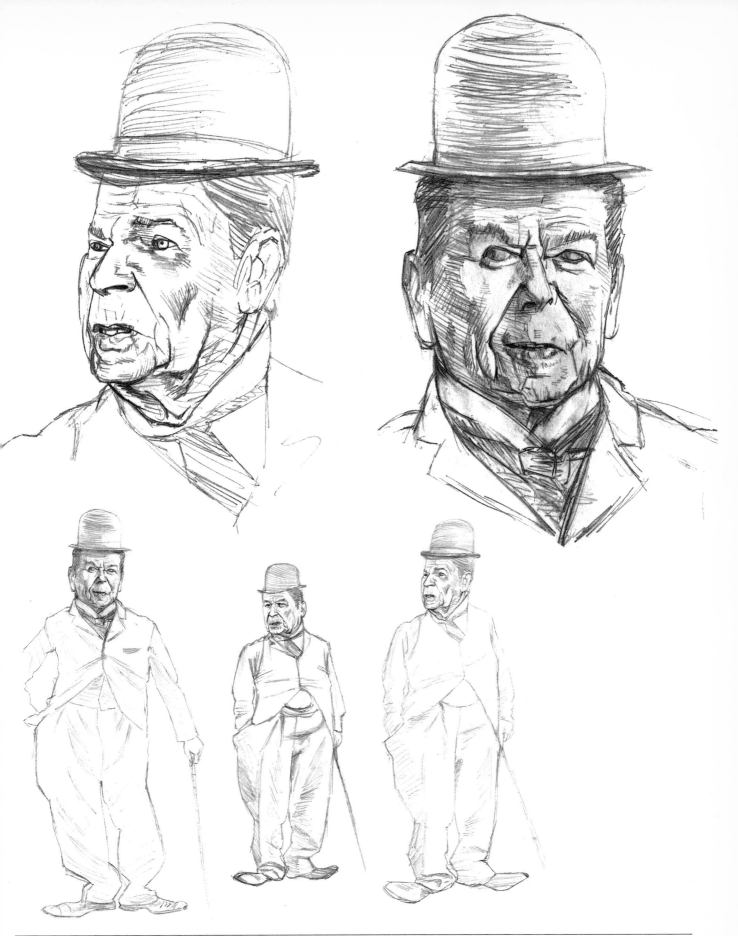

HOFMEKLER'S PEOPLE

"Let friend and foe alike know America has the muscle to back up its word."

REAGAN, Ronald Wilson; American politician and former actor; b. 6 Feb. 1911, Tampico, Ill.; s. of John Edward and Nelle (Wilson) Reagan; m. 1st Jane Wyman 1940 (divorced 1948), one s. one d.; m. 2nd Nancy Davis 1952, one s. one d.; ed. Northside High School, Dixon, Ill., and Eureka Coll.; U.S. Air Force 1942 – 46; Gov. of Calif. 1967 – 74; Pres. of U.S.A. Jan. 1981 – ; Chair. Republican Govs. Asscn. 1969; fmr. film actor and producer, radio sports announcer (at Des Moines, Iowa) and Ed., Cen. Broadcasting Co.; operated horsebreeding and cattle ranch; Player and Production Supervisor, Gen. Electric Theater TV for eight years; fmr. Pres. Screen Actors Guild, Motion Picture Industry Council; mem. Bd. of Dirs. Cttee. on Fundamental Educ., St. John's Hosp.; Dr. h.c. (Notre Dame, Ind.) 1981; numerous awards; Republican. *Films acted in include:* Love is on the Air 1937, Accidents Will Happen 1938, Dark Victory 1939, Hell's Kitchen 1939, Brother Rat and a Baby 1940, Santa Fé Trail 1940, International Squadron 1941, Nine Lives are Not Enough 1941, King's Row 1941, Juke Girl 1942, Desperate Journey 1942, This is the Army 1943, Stallion Road 1947, That Hagen Girl 1947, The Voice of the Turtle 1947, Night unto Night 1948, John Loves Mary 1949, The Hasty Heart (Great Britain) 1949, Louisa 1950, Storm Warning 1951, Bedtime for Bonzo 1951, Hong Kong 1952, Prisoner of War 1954, Law and Order 1954, Tennessee's Partner 1955, Hellcats of the Navy 1957, The Killers 1964. *Publication:* Where's the Rest of Me? (autobiography), reprinted as My Early Life 1981. *Address:* The White House, 1600 Pennsylvania Avenue, Washington, D.C. 20500, U.S.A.

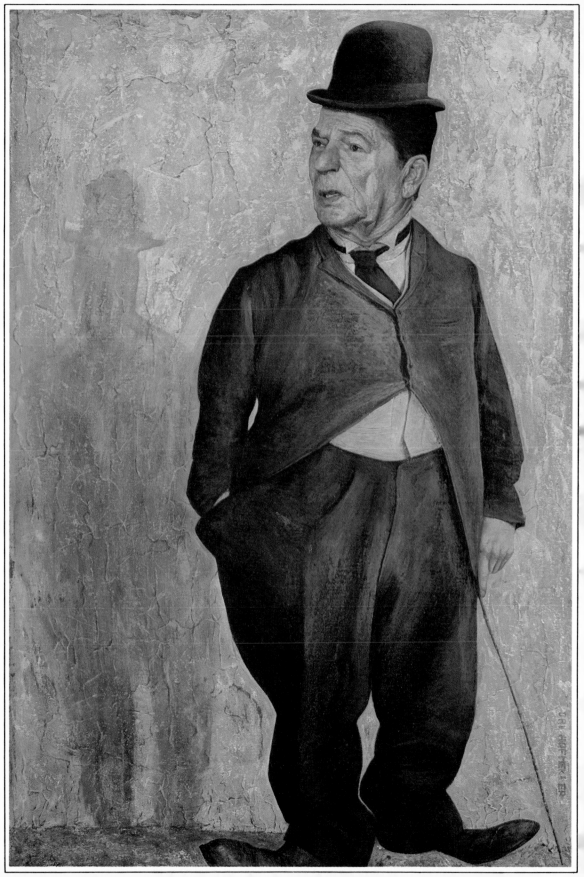

Haig

ALEXFIGHTER HAIG

GREAT ALEXANDER

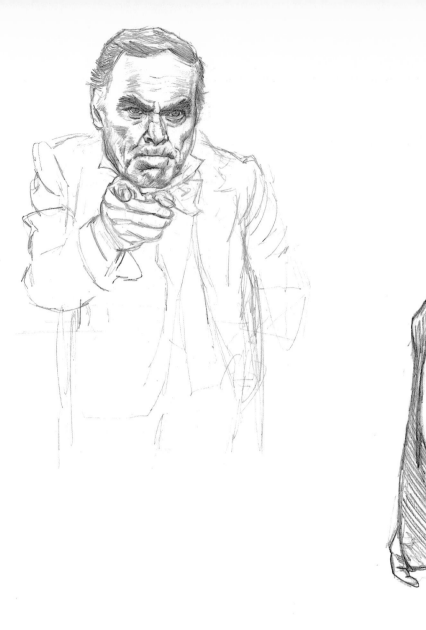

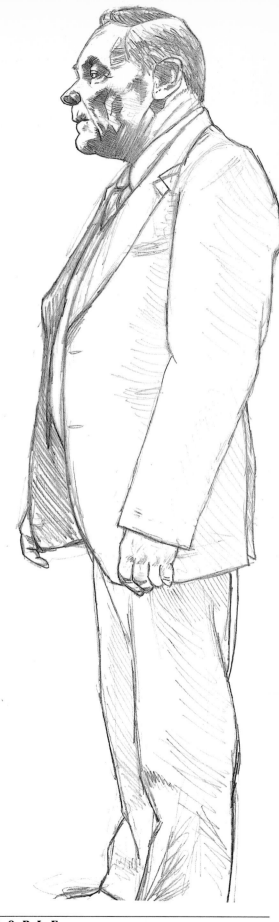

"I am in control here."

HAIG, Gen. Alexander Meigs, Jr.; American army officer and politician; b. 2 Dec. 1924, Philadelphia, Pa.; s. of Alexander M. and Regina Murphy Haig; m. Patricia Fox 1950; two s. one d.; ed. U.S. Mil. Acad., Naval War Coll. and Georgetown Univ.; joined U.S. Army 1947, rising to Brig.-Gen. 1969, Maj.-Gen. 1972, Gen. 1973; Deputy Special Asst. to Sec. and Deputy Sec. of Defence 1964 – 65; Battalion and Brigade Commdr. 1st Infantry Div., Repub. of Viet-Nam 1966 – 67; Regimental Commdr. and Deputy Commdt. U.S. Mil. Acad. 1967 – 69; Sr. Mil. Advisor to Asst. to Pres. for Nat. Security Affairs, the White House 1969 – 70; Deputy Asst. to Pres. for Nat. Security Affairs 1970 – 73; Vice-Chief of Staff, U.S. Army Jan.-July 1973; special emissary to Viet-Nam Jan. 1973; retd. from U.S. Army Aug. 1973; Asst. to Pres. and White House Chief of Staff Aug. 1973 – Oct. 1974; recalled to active duty, U.S. Army Oct. 1974; C.-in-C., U.S. European Command 1974 – 79; Supreme Allied Commdr. Europe, NATO 1979; Dir. ConAgra 1979 – 81; Pres., C.O.O. and Dir. United Technologies Corpn. 1980 – 81; Sec. of State Jan. 1981 – ; Hon. LL.D. (Utah and Niagara); Gold Medal Nat. Inst. of Social Sciences 1980; numerous medals and awards. *Leisure interests:* tennis golf, squash, horse-riding. Resigned; 25 June, 1982.

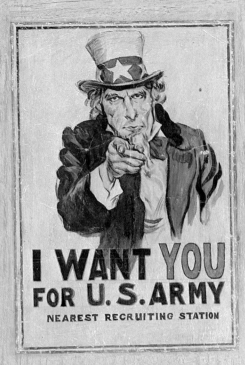

ORI HOFMEKLER

Kennedy

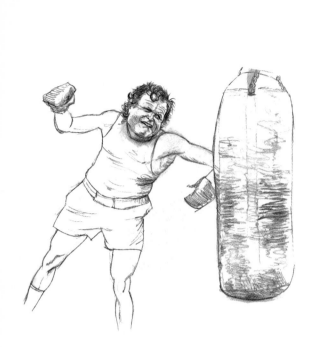

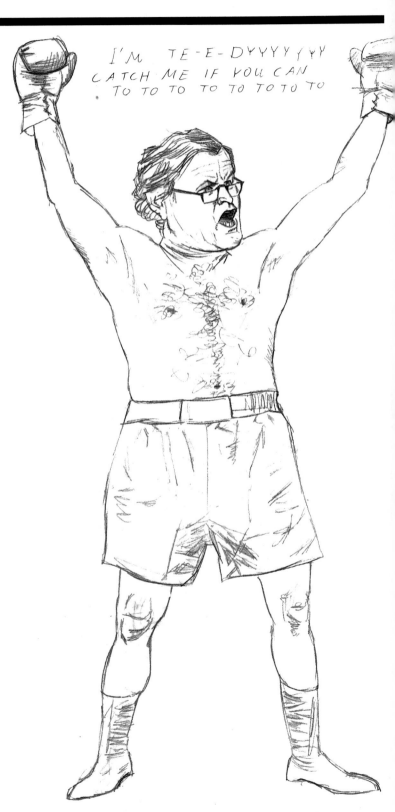

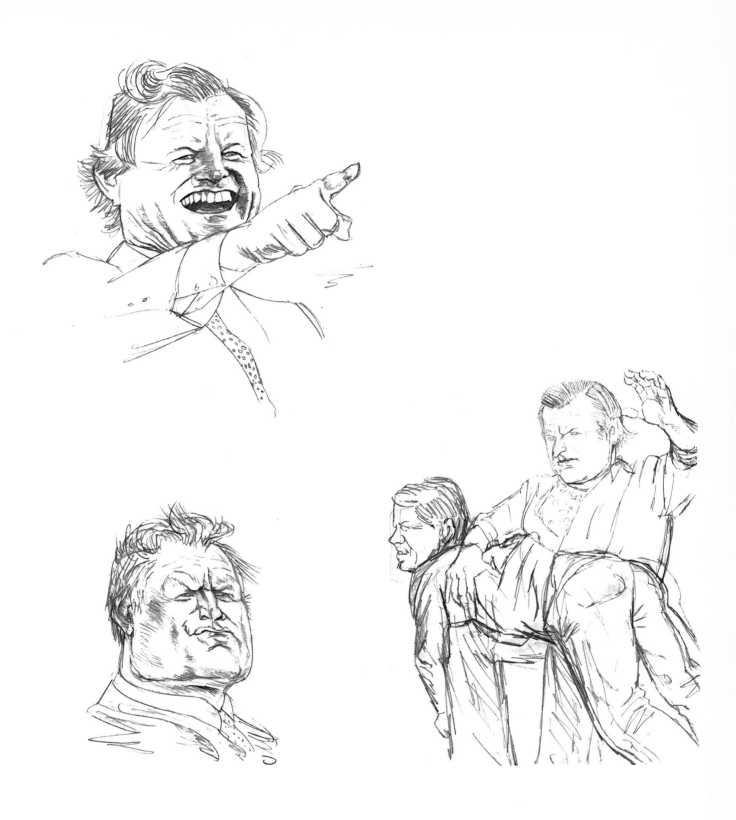

"I'm only interested in getting re-elected to the Senate."

KENNEDY, Edward Moore, A.B., LL.B.; American lawyer and politician; b. 22 Feb. 1932, Boston, Mass.; s. of late Joseph Kennedy and of Rose Kennedy; brother of late Pres. John F. Kennedy; m. Virginia Joan Bennett 1958; two s. one d.; ed. Milton Acad., Harvard Coll. and Univ. of Virginia Law School; U.S. Army, Infantry, Private 1st Class 1951 – 53; Reporter, Int. News Service, N. Africa 1956; Man. Western States, John F. Kennedy Presidential Campaign 1960; fmr. Asst. District Attorney, Mass.; U.S. Senator from Massachusetts 1963 – ; Asst. Majority Leader, U.S. Senate 1969 – 71; Pres. Joseph P. Kennedy Jr. Foundation 1961 – ; Trustee, Boston Univ., Boston Symphony, John F. Kennedy Library, Lahey Clinic, Boston, John F. Kennedy Center for the Performing Arts, Robert F. Kennedy Memorial Foundation; Bd. mem. Fletcher School of Law and Diplomacy, Mass. Gen. Hospital; mem. Bd. Advisers, Dunbarton Oaks Research Library and Collections; numerous hon. degrees; Order of the Phoenix (Greece) 1976; Democrat. *Publications:* Decisions for a Decade 1968, In Critical Condition 1972, Our Day and Generation 1979. *Address:* Senate Office Building, Washington, D.C. 20510, U.S.A.

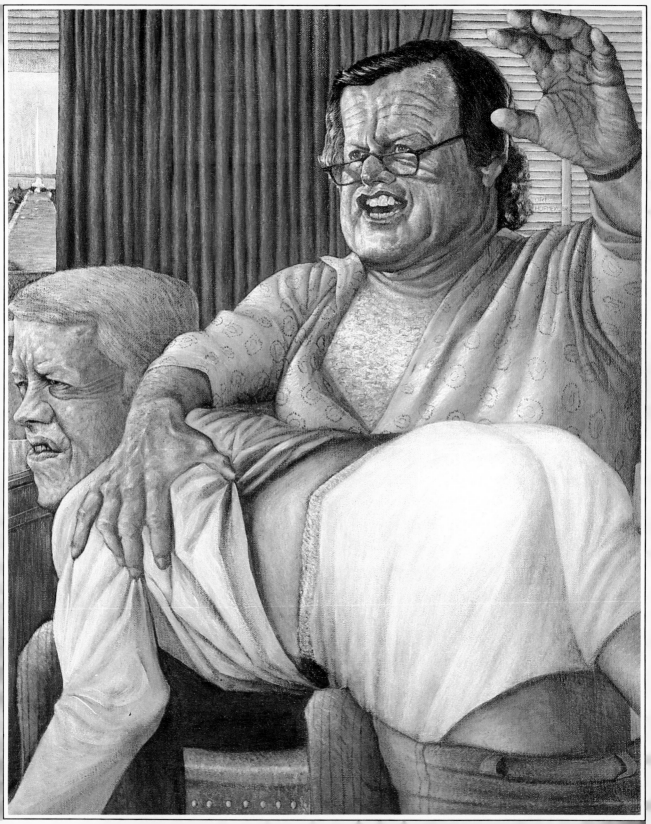

Carter and Family

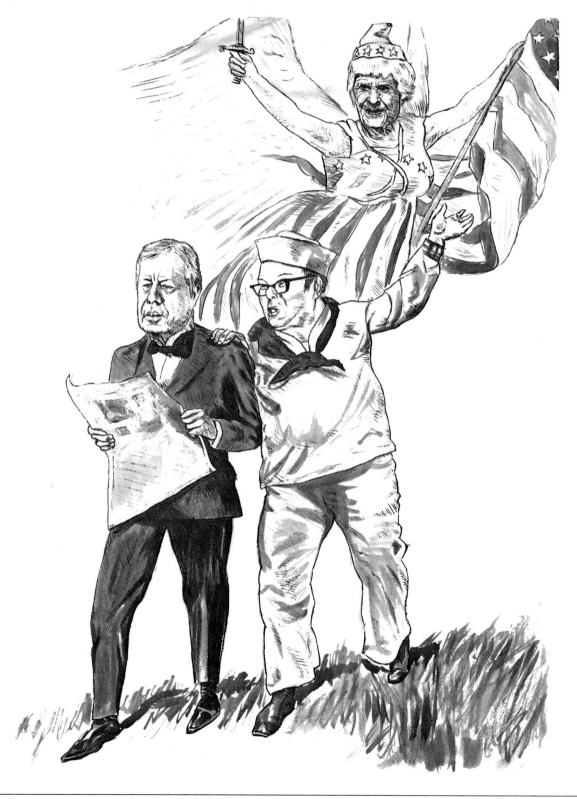

THE Mother suckker

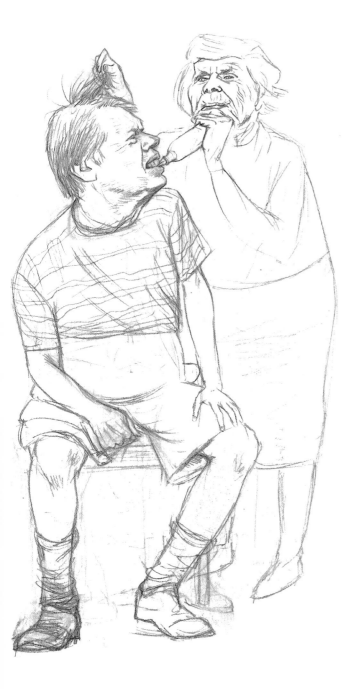

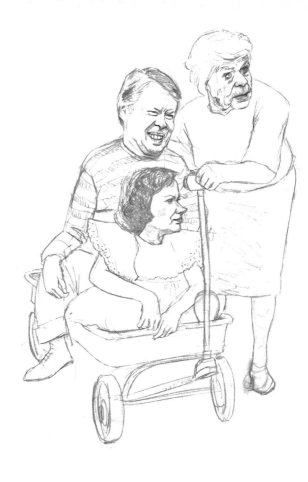

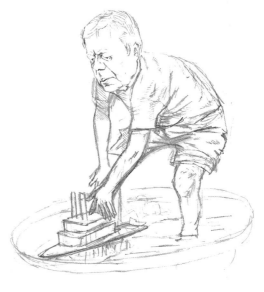

"I grow peanuts over in Georgia."

CARTER, Jimmy (James Earl, Jr.); American farmer and politician; b. 1 Oct. 1924, Plains, Ga.; s. of James Earl Carter Sr. and Lillian Gordy; m. Rosalynn Smith 1946; three s. one d.; ed. Plains High School, Georgia Southwestern Coll., Georgia Inst. of Tech., U.S. Naval Acad., Annapolis, Md.; served U.S. Navy 1964 – 53, attained rank of Lieut.-Commdr.; peanut farmer, warehouseman 1953, businesses Carter Farms, Carter Warehouses, Ga.; State Senator, Ga. 1962 – 66; Gov. of Georgia 1971 – 74; Pres. of U.S.A. 1977 – 81; Democrat, *Leisure interests:* reading, tennis. *Address:* 1 Woodland Drive, Plains, Ga. 31780, U.S.A. (Home).

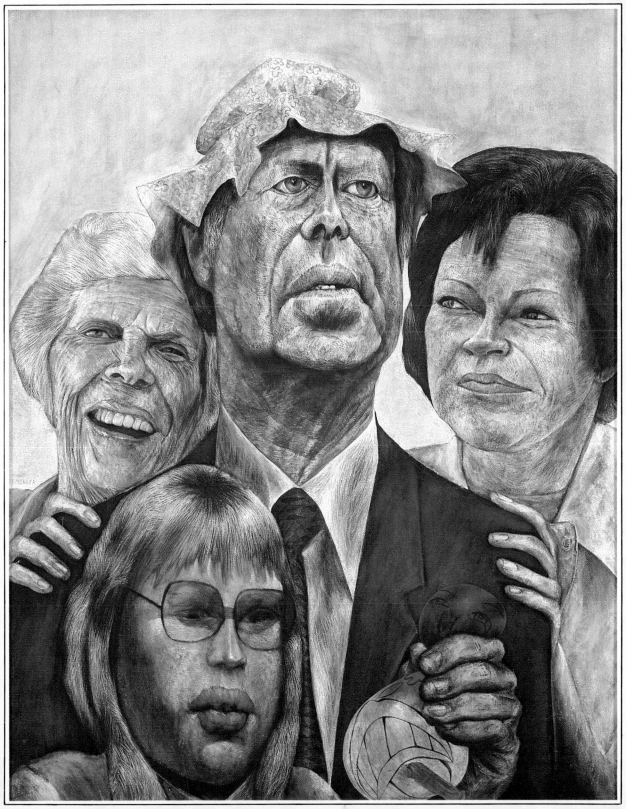

Carter and Friends

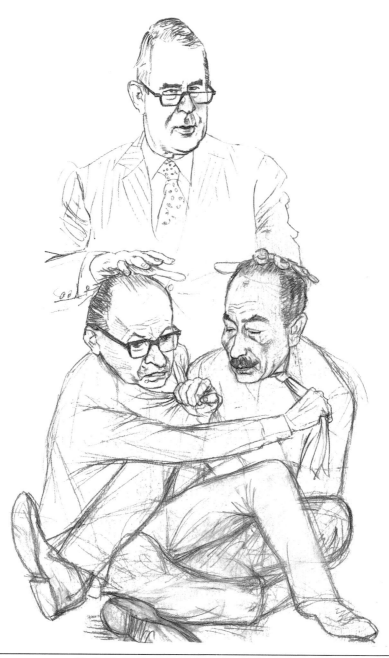

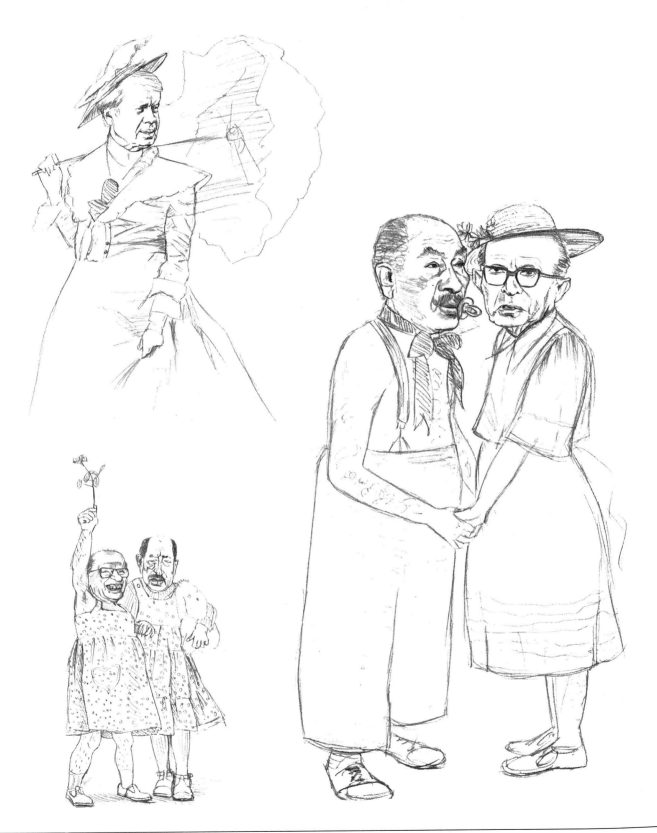

"We hope the Palestinian people will seize this historic opportunity."

VANCE, Cyrus Roberts, B.A., LL.B.B.: American lawyer and former government official; b. 27 March 1917, Clarksburg, W. Va.; s. of John Carl and Amy Roberts Vance; m. Gracie Elsie Sloane 1947; one s. four d.; ed. Kent School and Yale Univ.; Lieut., U.S. Navy 1942-46; Asst. to Pres. The Mead Corpn. 1946-47; Simpson, Thatcher and Bartlett, New York (law firm) 1947-, Partner 1956-61, 1967-76, 1980-; Special Counsel, Preparedness Investigating Subctee., Cttee. on Armed Services of the U.S. Senate 1957-60; Consulting Counsel to Special Cttee. on Space and Astronautics, U.S. Senate 1958; Gen. Counsel, Dept. of Defense 1961-62; Chair. Cttee. Adjudication of Claims of the Admin. Conf. of the U.S. 1961-62; Sec. of the Army 1962-64; Deputy Sec. of Defense 1964-67; Pres. Johnson's Special Envoy on Cyprus Situation 1967, on Korean Situation 1968; negotiator at Paris talks on Viet-Nam 1968-69; mem. Cttee. investigating Alleged Police Corruption, New York 1970-72, Ind. Comm. on Disarmament and Security 1980-; Pres. Bar Asscn. of City of New York 1974-76; Chair. UN Devt. Corpn. 1976; Sec. of State Jan. 1977-80 (resgnd.); Dir. Mfrs. Hanover Corpn., Mfrs. Hanover Trust 1981-, IBM Corpn., U.S. Steel Co.; fmr. Chair. Bd. of Rockefeller Foundation; mem. U.S. Supreme Court, American Bar Asscn., N.Y. State Bar Asscn., Council of Foreign Relations; Fellow, American Coll. Trial Lawyers; Medal of Freedom 1969. *Address:* Simpson, Thatcher and Bartlett, One Battery Park Plaza, New York, N.Y. 10004, U.S.A.

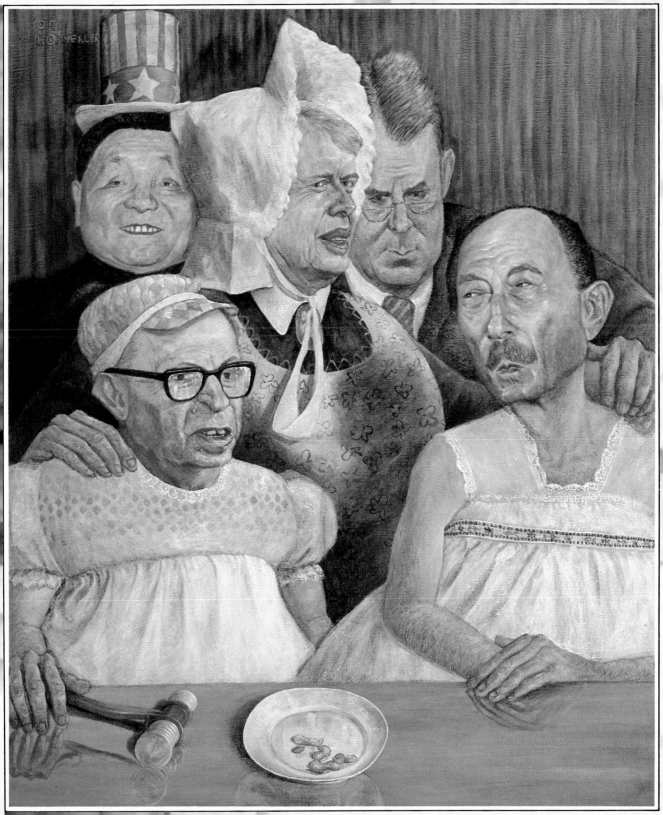

Trudeau

"My father taught me order and discipline and my mother freedom and fantasy."

TRUDEAU, Rt. Hon. Pierre Elliott, P.C., M.P.; Canadian lawyer and politician; b. 18 Oct. 1919, Montreal, Quebec; s. of Charles-Emile Trudeau and Grace Elliott; m. Margaret Sinclair 1971; three s.; ed. Collège Jean-de-Brébeuf, Montreal, Univ. of Montreal, Harvard Univ., Univ. of Paris, and L.S.E.; called to Bar, Province of Quebec 1943, then studied at Harvard, Paris and London; subsequently employed with Cabinet Secr., Ottawa; later practised law, Province of Quebec; one of founders of Cité Libre (Quebec review); Assoc. Prof. of Law, Univ. of Montreal 1961; mem. House of Commons 1965 – ; Parl. Sec. to Prime Minister 1966 – 67; Minister of Justice and Attorney-Gen. 1967 – 68; Leader of Liberal Party April 1968 – ; Prime Minister of Canada 1968 – 79, Feb. 1980 – ; Dr. h.c. (Duke Univ., Durham, N.C., U.S.A.) 1974; Freedom of City of London 1975. *Publications:* La grève de l'amiante 1956, Canadian Dualism/La dualité Canadienne 1960, Deux innocents en Chine rouge 1961, Federalism and the French Canadians 1968, Réponses 1968; and numerous articles in Canadian and foreign journals. *Address:* Office of the Prime Minister, Langevin Block, Parliamentary Buildings, Ottawa, Ont. K1A 0A2, Canada.

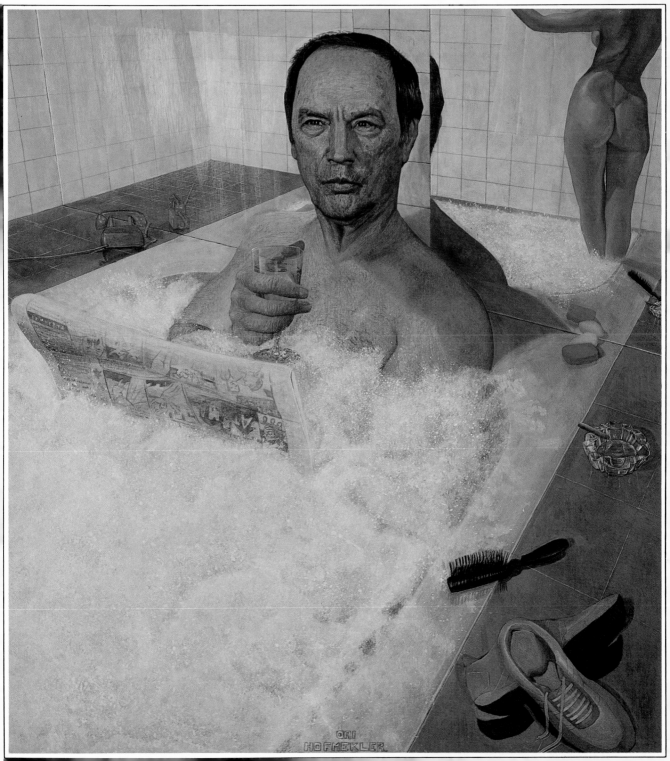

Castro

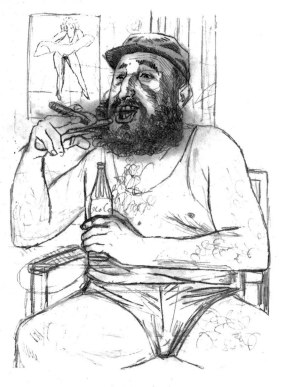

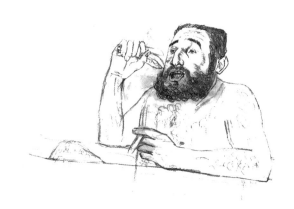

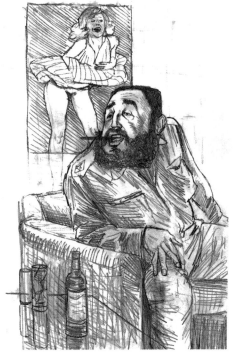

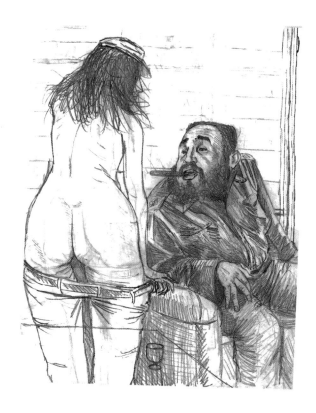

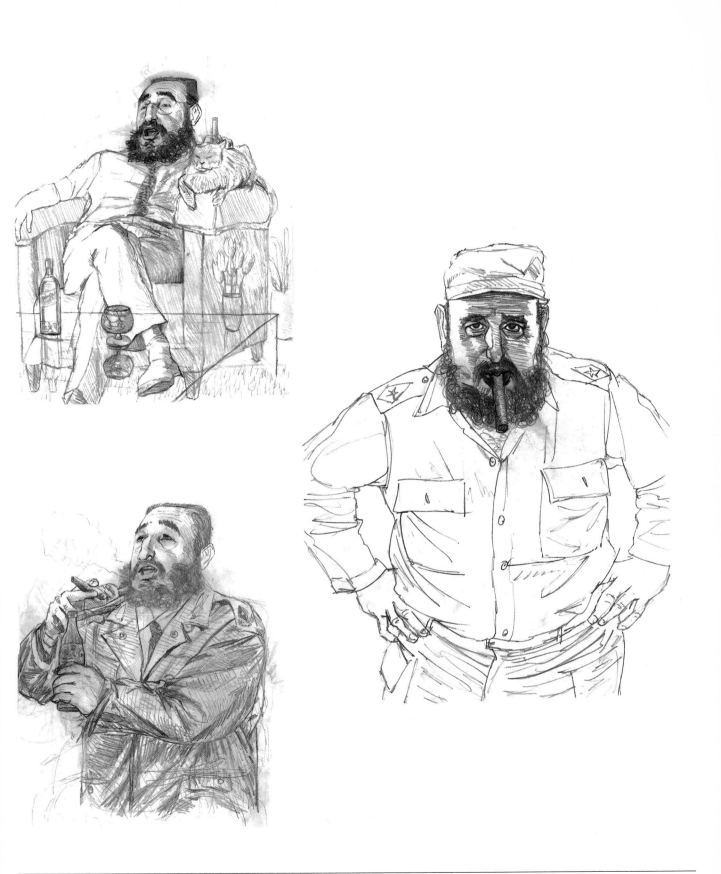

"Men are very fragile. We disappear and go up in smoke for almost any reason."

CASTRO RUZ, Fidel, D.IUR.; Cuban politician; b. 13 Aug. 1927; ed. Jesuit schools in Santiago and Havana, Univ. de la Habana; law practice in Havana; began active opposition to Batista regime by attack on Moncada barracks at Santiago 26th July 1953; sentenced to 15 years' imprisonment 1953; amnestied 1956; went into exile in Mexico and began to organize armed rebellion; landed in Oriente Province with small force Dec. 1956; carried on armed struggle against Batista regime until flight of Batista Jan. 1959; Prime Minister of Cuba 1959 – 76; Head of State and Pres. of Council of State 1976 – , Pres. of Council of Ministers 1976 – ; Chair. Agrarian Reform Inst. 1965 – ; First Sec. Partido Unido de la Revolucion Socialista (PURS) 1963 – 65, Partido Comunista 1965 – (mem. Political Bureau 1976 –); Lenin Peace Prize 1961; Dimitrov Prize (Bulgaria) 1980; Hero of the Soviet Union 1963; Order of Lenin 1972, Order of the October Revolution 1976, Somali Order (1st Class) 1977, Order of Jamaica 1977. *Publications:* Ten Years of Revolution 1964, History Will Absolve Me 1968. *Address:* Palacio del Gobierno, Havana, Cuba.

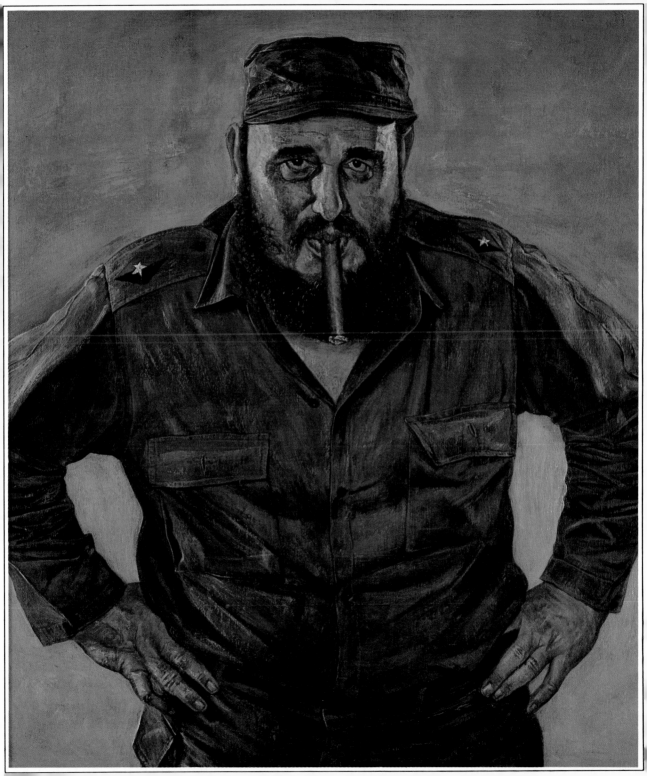

Brezhnev

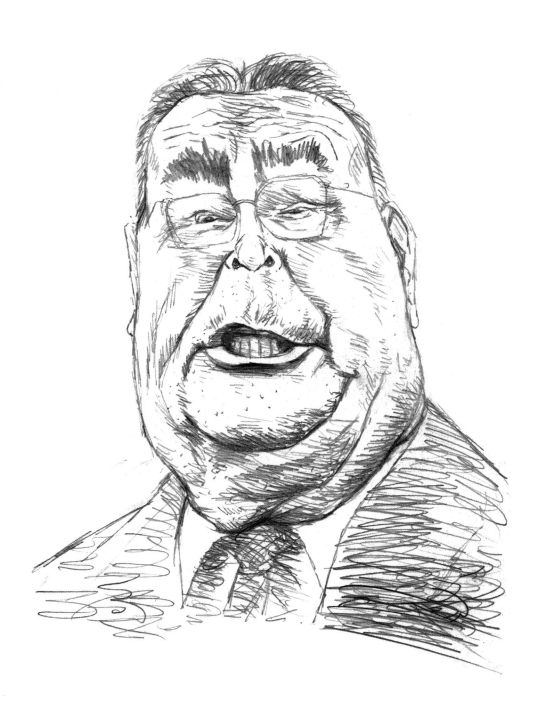

"God will not forgive us if we fail."

BREZHNEV, Leonid Ilyich; Soviet politician; b. 19 Dec. 1906, Dneprodzerzhinsk, Ukraine; ed. secondary school for Land Organization and Reclamation, Kursk, and Dneprodzerzhinsk Metallurgical Inst.; Chief of District and Land Dept., Deputy Chair. of District Exec. Cttee., later Deputy Chief, Urals Regional Land Dept. 1927 – 30; student Dneprodzerzhinsk Metallurgical Inst. 1931 – 35; Engineer, Dneprodzerzhinsk Metallurgical Plant 1935; Soviet Army 1935 – 36; Deputy Chair. Exec. Cttee. Dneprodzerzhinsk City Council, Chief of Dept., Dnepropetrovsk Regional Party Cttee. 1937 – 39, Sec. 1939 – 41; Political Officer, Soviet Army 1941 – 46, to Maj. -Gen. 1944; First Sec. Zaphorozhye Regional Party Cttee., Ukraine CP 1946 – 47, Dnepropetrovsk Regional Party Cttee. 1947 – 50; First Sec. Cen. Cttee., CP of Moldavia 1950 – 52; mem. Cen. Cttee. of CPSU 1952 – ; Alt. mem. Presidium 1952 – 53, Sec. Cen. Cttee. of CPSU 1952 – 53; Deputy Chief Cen. Political Dept., Soviet Army and Navy 1953 – 54; Second Sec. Cen. Cttee. of Kazakh CP 1954, First Sec. 1955 – 56; Alt. mem. Presidium Cen. Cttee. of CPSU 1956 – 57, mem. 1957 – 66, mem. Politburo 1966 – ; Sec. Cen. Cttee. of CPSU 1956 – 60; Chair. of Presidium of Supreme Soviet of U.S.S.R. (Head of State) 1960 – 64, June 1977 – ; Sec. Cen. Cttee. of CPSU 1963, First Sec. 1964 – 66, Gen. Sec. April 1966 – ; Chair. of Defence Council of U.S.S.R.; Marshal of the Soviet Union 1976; Hero of Socialist Labour 1961, Hero of the Soviet Union, Gold Star Medal 1966, 1976, 1978, Hammer and Sickle Gold Medal, Order of Victory, Orders of Lenin, October Revolution, Red Banner, Int. Lenin Peace Prize, Int. Dmitrov Peace Prize, Lenin Literature Prize, UN Gold Medal of Peace, Int. Gold Mercury Prize for Peace and Co-operation, and many other Soviet, foreign and int. decorations. *Publications:* Following Lenin's Course (7 vols.), Little Land, Rebirth, Virgin Lands, Socialism, Democracy and Human Rights. *Address:* Central Committee of the Communist Party of the Soviet Union, 4 Staraya ploshchad, Moscow, U.S.S.R. d. November 10, 1982.

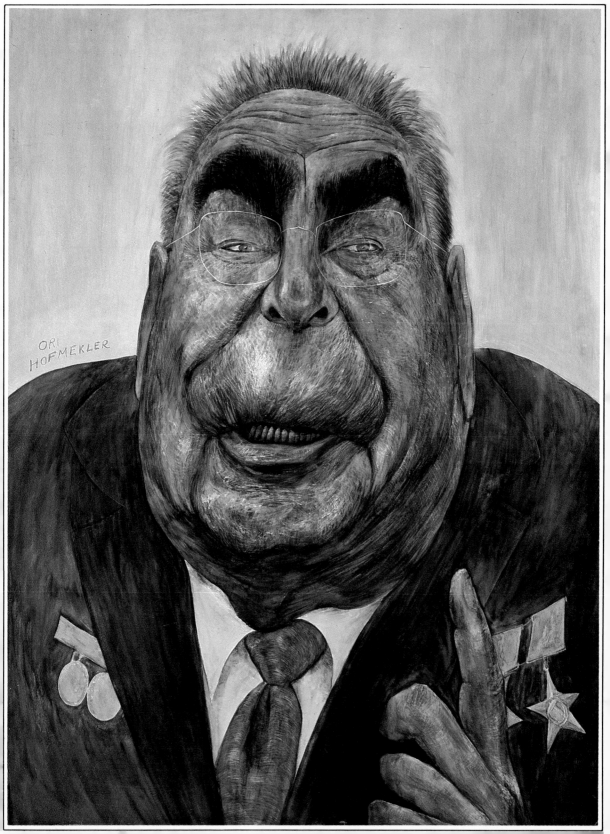

Walesa

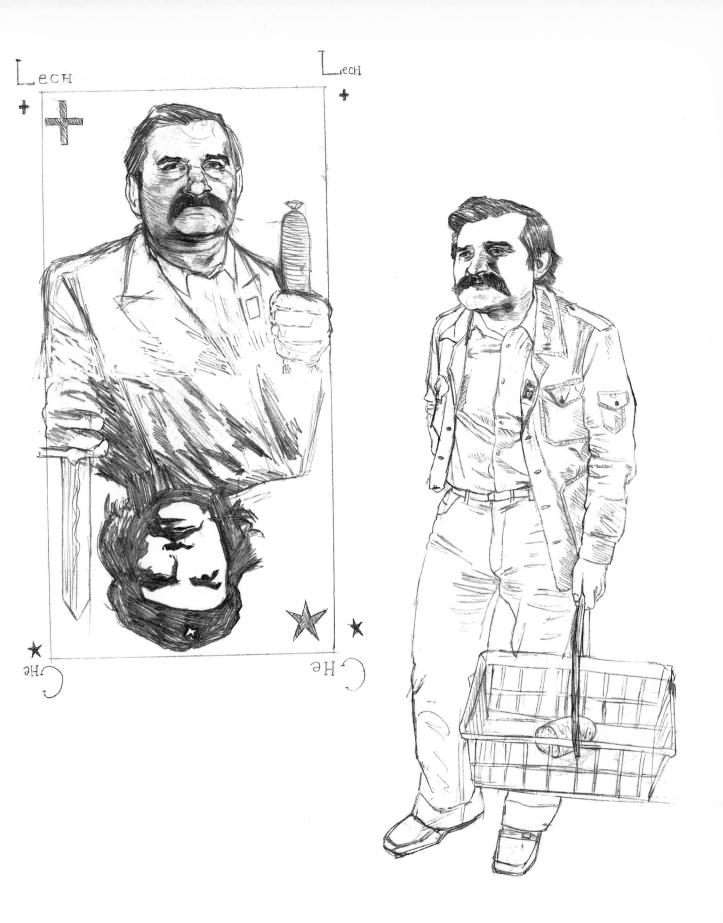

"If you choose the example of what we have in our pockets and in our shops, then I answer that Communism has done very little for us. If you choose the example of what is in our souls instead, I answer that Communism has done very much for us. Our souls contain exactly the contrary of what they wanted."

WALESA, Lech; Polish trade union activist; b. 29 Sept. 1943, Popowo; s. of the late Boleslaw and of Feliksa Walesa; m. Miroslawa Walesa 1969; four s. three d.; ed. primary and tech. schools; electrician, Lenin Shipyard, Gdansk 1966 – 76; unemployed 1976 – 80; Chair. Strike Cttee. in Lenin Shipyard 1970; Chair.

Inter-institutional Strike Cttee., Gdansk Aug.-Sept. 1980; Chair. Nat. Co-ordinating Comm. of Independent Autonomous Trade Union "Solidarity" (NSZZ Solidarnosc), Chair. (elect) All-Poland Understanding Comm. NSZZ Solidarnosc Sept. 1980 – ; mem. State Comm. for Formulation of Trade Union Activity; detained Dec. 1981 -

; Freedom Medal (Philadelphia) 1981, Free World (Prize (Norway) 1982. *Leisure interest:* fishing. *Address:* formerly Komisja Krajowa NSZZ "Solidarnosc", ul. Grunwaldzka 103, 80-244 Gdansk (Office); ul. Pilotow 17D/3, Gdansk-Zaspa, Poland (Home).

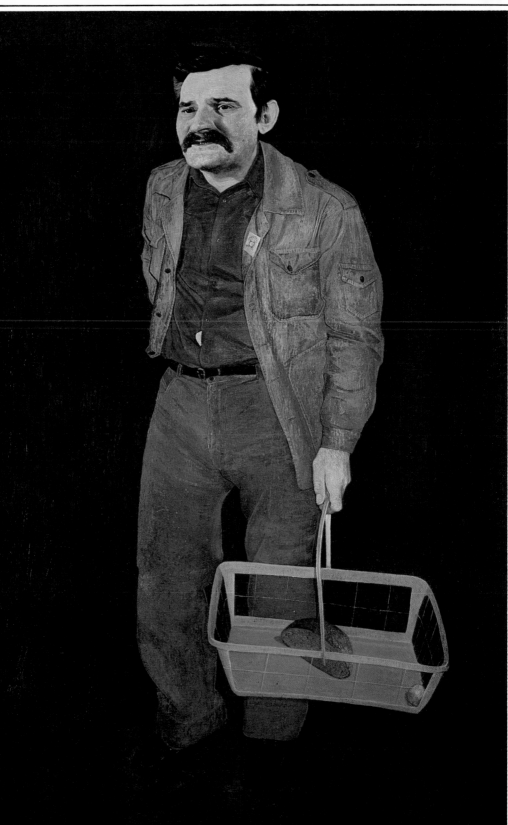

Arafat

THE LEBANON DIET PRESCRIPTION

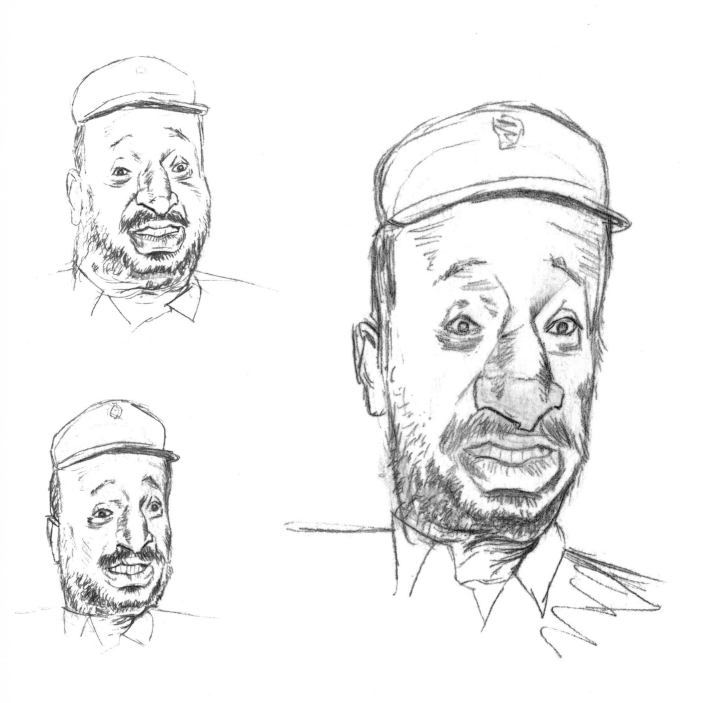

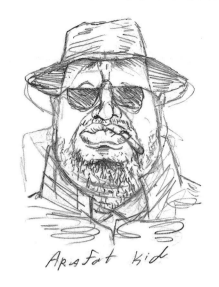

Arafat kid

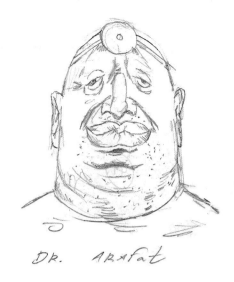

DR. ARAFAT

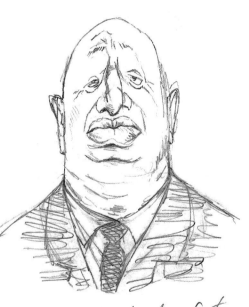

civilized Arafat

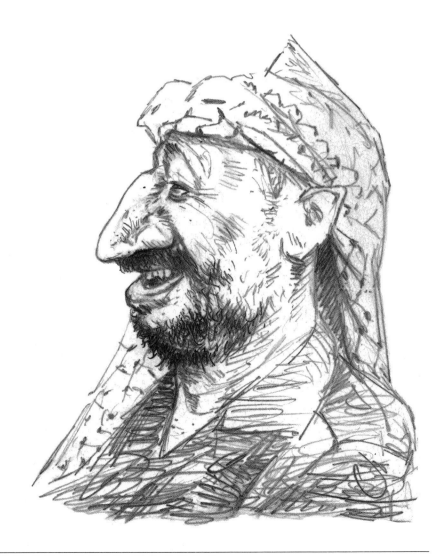

"The only thing to say about me is that I'm a humble Palestinian fighter."

ARAFAT, Yasser (pseudonym of Mohammed Abed Ar'ouf Arafat); Palestinian resistance leader; b. 1929, Jerusalem; ed. Cairo Univ.; joined League of Palestinian Students 1944, mem. Exec. Cttee. 1950, Pres. 1952 – 56; formed, with others, Al Fatah movt. 1956; engineer in Egypt 1956, Kuwait 1957 – 65; Pres. Exec. Cttee. of Palestine Nat. Liberation Movement (Al Fatah) June 1968 – ; Chair. Exec. Cttee. Palestine Liberation Org. 1968 – , Pres. Cen. Cttee., Head, Political Dept. 1973 – ; Gen. Commdr. Palestinian Revolutionary Forces; addressed UN Gen. Assembly Nov. 1974; Joliot-Curie Gold Medal, World Peace Council Sept. 1975. *Address:* Tunis, Tunisia.

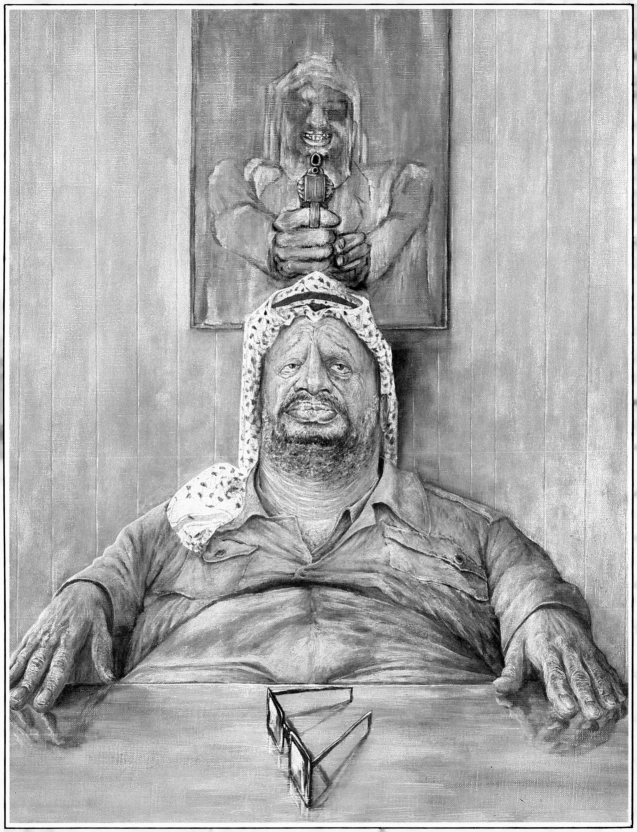

Sadat

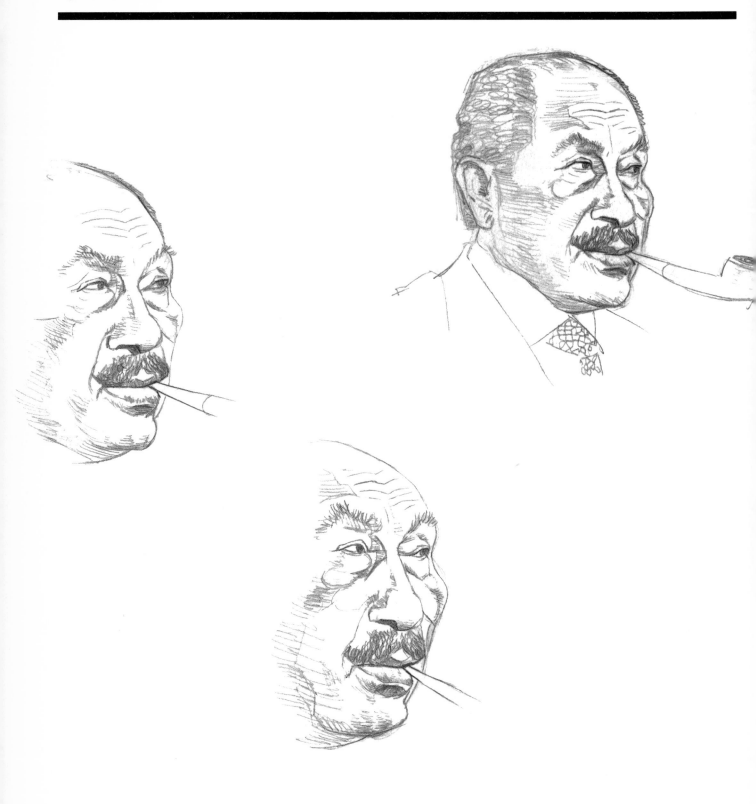

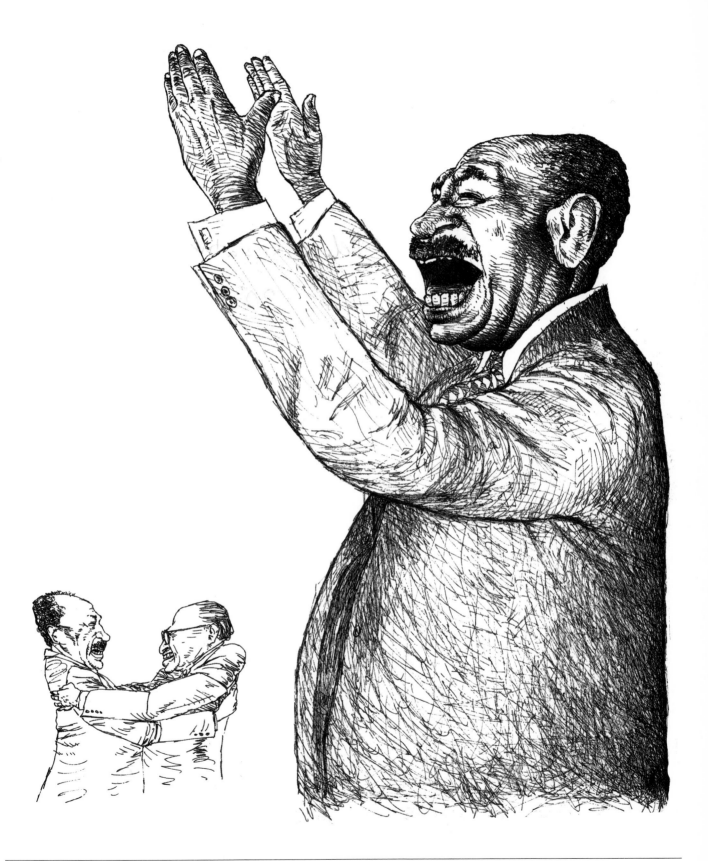

"The dogs can go on barking, but they will not stop the caravan."

SADAT, Col. Mohamed Anwar El-; Egyptian army officer and politician; b. 25 Dec. 1918, Tala Dist., Menufia Governorate; s. of Mohamed El-Sadat; m. Jihan Sadat; one s. three d. (also three d. by previous marriage); ed. Military Coll.; commissioned 1938; fmr. Gen. Sec. Islamic Congress; participated in Officers' coup 1952; Ed. Al Jumhuriya and Al Tahrir 1955 – 56; Minister of State 1955 – 56; Vice-Chair. Nat. Assembly 1957 – 60, Chair. 1960 – 68; Gen. Sec. Egyptian Nat. Union 1957 – 61; Chair. Afro-Asian Solidarity Council 1961; Speaker U.A.R. Nat. Assembly 1961 – 69; mem. Presidential Council 1962 – 64; Vice-Pres. of Egypt 1964 – 66, 1969 – 70; interim Pres. of Egypt Sept.-Oct. 1970, Pres. Oct. 1970 – , Prime Minister 1973 – 74, May 1980 – ; proclaimed Military Gov.-Gen. March 1973; Pres. Council Fed. of Arab Repubs. 1971 – ; Chair. Arab Socialist Union 1970 – , mem. Higher Council on Nuclear Energy 1975 – ; Sinai Medal 1974; awarded Nobel Prize for Peace (shared with Prime Minister Begin q.v.) 1978; Methodist Peace Prize 1978; decorations from Yugoslavia 1956, Greece 1958, German Democratic Repub. 1965, Romania, Finland 1967, Iran 1971, Saudi Arabia 1974 and others. *Publications:* Unknown Pages 1955, The Secrets of the Egyptian Revolution 1957, The Story of Arab Unity 1957, My Son, this is your Uncle Gamal 1958, The Complete Story of the Revolution 1961, For a New Resurrection 1963, In Search of Identity (autobiog). 1978. d. 6 Oct. 1981.

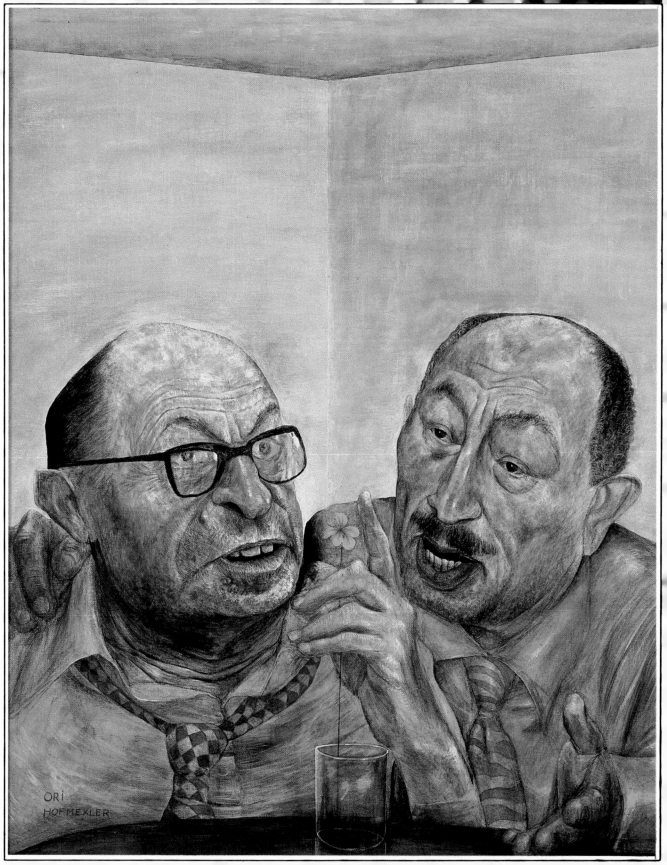

Begin

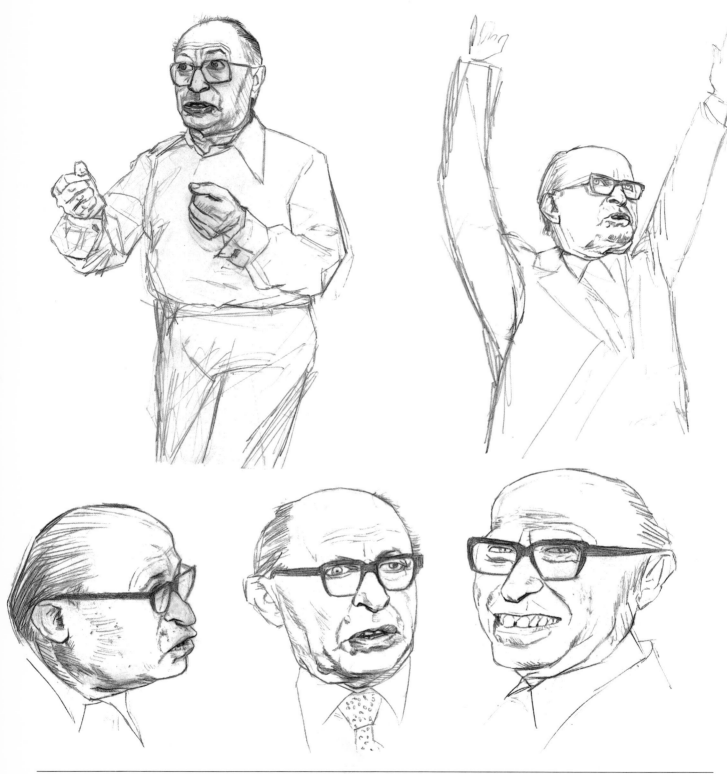

DAVID OF THE BIBLE

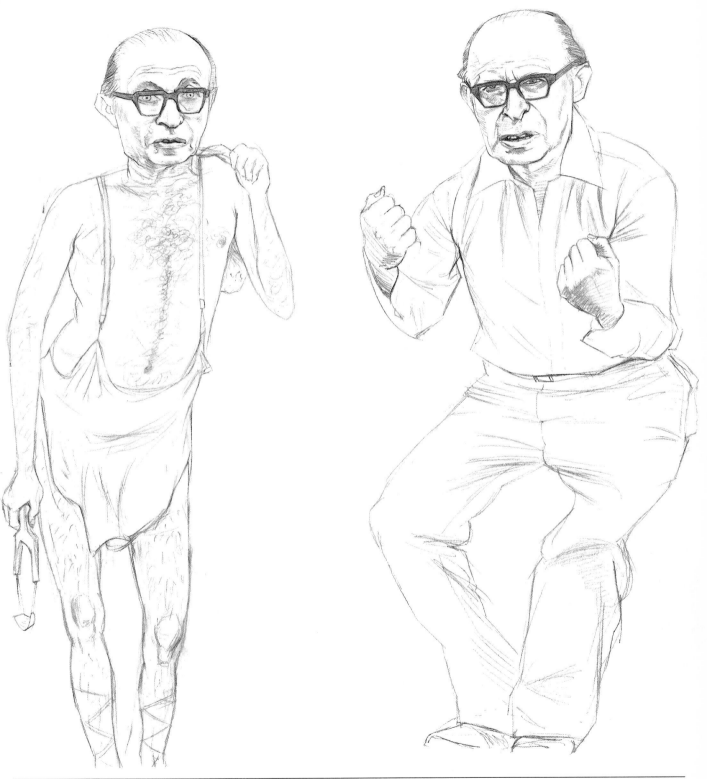

"I owe you an explanation."

BEGIN, Menachem, M.J.; Israeli lawyer and politician; b. 16 Aug. 1913, Brest-Litovsk, Russia; s. of Zeev-Dov and Hassia Begin; m. Aliza Arnold; one s. two d.; ed. Mizrachi Hebrew School, Univ. of Warsaw; Head of Betar Zionist Youth Movement in Poland 1939; arrested and held in concentration camp in Siberia 1940 – 41; C.-in-C. of Irgun Zvai Leumi in Israel 1942; founded (now Chair.) Herut (Freedom) Movement in Israel 1948 – ; mem. Knesset (Parl.); Minister without Portfolio 1967 – 70; Prime Minister June 1977 – , Minister of Defence May 1980 – ; Joint Chair. Likud (Unity) Party 1973 – ; Hon. Dir. (Bar Ilan Univ.); Hon. D. Litt. (Yeshiva Univ., N.Y.) 1978; Nobel Prize for Peace (shared with Pres. Sadat) 1978. *Publications:* The Revolt: Personal Memoirs of the Commander of Irgun Zvai Leumi 1949, White Nights 1957, 1977, In the Underground (writings and documents) 1978. *Address:* Office of the Prime Minister, Jerusalem; 1 Rosenbaum Street, Tel-Aviv, Israel (Home).

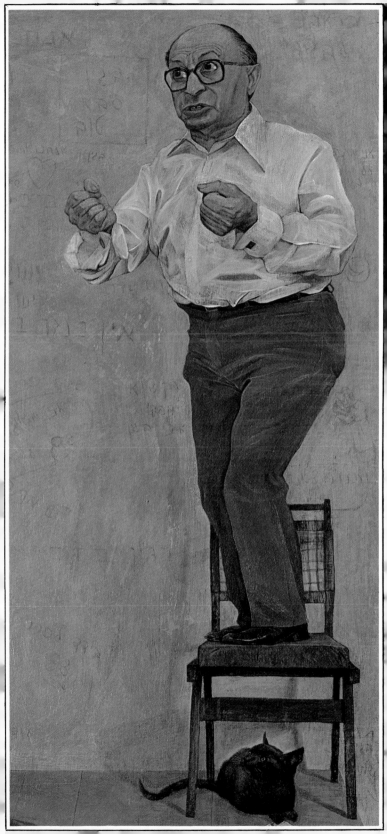

Sharon

"I'd rather have a dead terrorist than a live one in jail."

SHARON, Major-Gen. Ariel; Israeli army officer (retd.) and politician; b. 1928; m.; two s.; active in Hagana since early youth; Instructor, Jewish Police units 1947; Platoon Commdr. Alexandroni Brigade; Regimental Intelligence Officer 1948; Co. Commdr. 1949; Commdr. Brigade Reconnaissance Unit 1949 – 50; Intelligence Officer, Cen. Command and Northern Command 1951 – 52; studies at Hebrew Univ. 1952 – 53; in charge of Unit 101, on numerous reprisal operations until 1957, Commdr. Paratroopers Brigade, Sinai Campaign 1956; studies Staff Coll., Camberley, U.K. 1957 – 58; Training Commdr., Gen. Staff 1958; Commdr. Infantry School 1958 – 69; Commdr. Armoured Brigade 1962; Head of Staff, Northern Command 1964; Head, Training Dept. of Defence Forces 1966; Head Brigade Group during Six-Day War 1967; resigned from Army July 1973; recalled as Commdr. Cen. Section of Sinai Front during Yom Kippur War Oct. 1973, forged bridgehead across Suez Canal; with others formed Likud Front Sept. 1973; mem. Knesset (Parl.) 1973 – 74, 1977 – ; Adviser to Prime Minister 1975 – 77; Minister of Agric. in charge of Settlements 1977 – 81, of Defence Aug. 1981 – . *Address:* Ministry of Defence, Jerusalem, Israel.

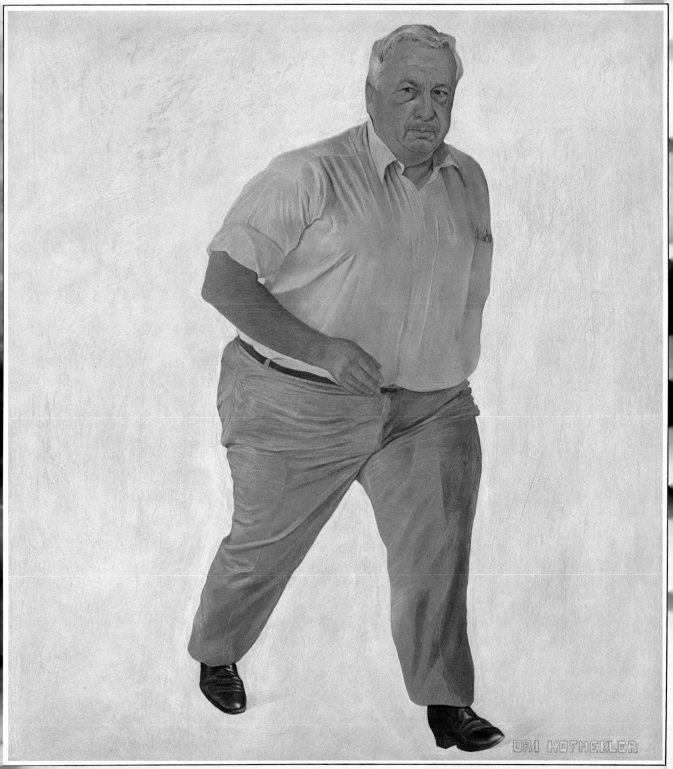

ORI HOFMEKLER

Dayan

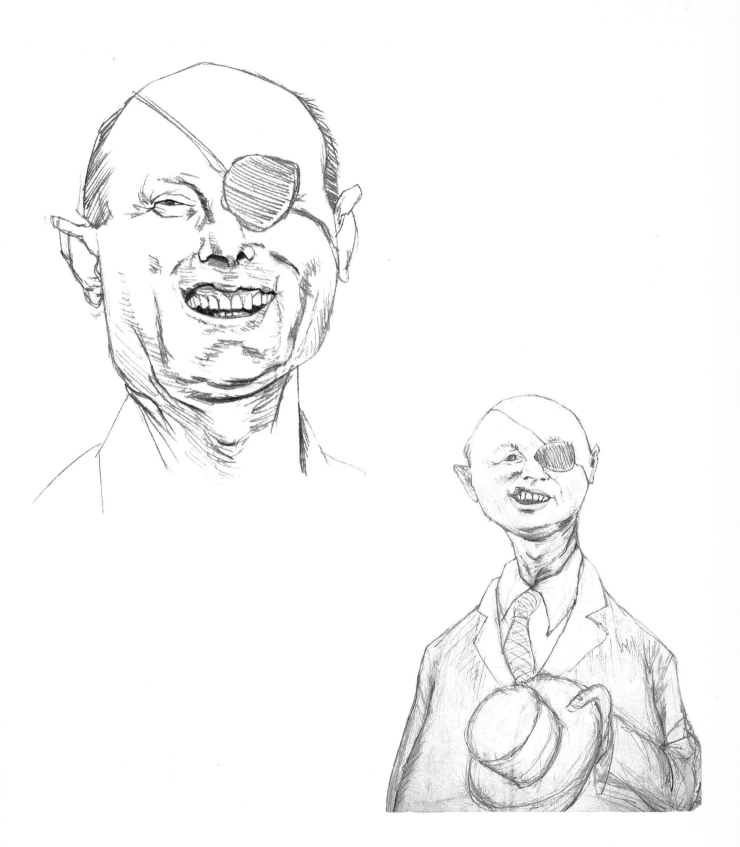

"I, Moshe Dyan, as an individual am not a coward. But as a Jew I am a very frightened man."

DAYAN, Lt.-Gen. Moshe, LL.B.; Israeli soldier and politician, b. 20 May 1915, Degania; s. of Dvora and Shmuel Dayan; m. 1st Ruth Schwartz 1935 (divorced 1972); m. 2nd Rachel Corem 1973; ed. agricultural high school, Nahalah, Staff Coll., Camberley, U.K. and Tel-Aviv Univ.; trained in Haganah (Jewish militia) 1929; second in command to Capt. Orde Wingate 1937; imprisoned by British when Haganah declared illegal 1939; released to lead reconnaissance and commando troops in Vichy Syria, wounded, losing eye 1941; intelligence work in Haganah 1941 – 48; Jordan Valley Front, "Dany" compaign 1948; promoted to Sgan-Aluf (Lt.-Col.) and named Commdr. Jerusalem front 1948; rep. Israel Defence Forces at Rhodes armistice talks with Jordan 1949; promoted to Aluf (Maj.-Gen.) and Commdr. Southern Region Command 1950; after military studies in U.K. appointed Commdr. Northern Region Command 1951; Head of Gen. Staff Branch at GHQ 1952; Chief of Gen. Staff 1953 – 58; studied at Faculty of Law, Tel-Aviv Univ. and in Jerusalem 1958 – 59; Minister of Agriculture 1959 – 64; resigned from Govt. 1964; joined Rafi party 1965; mem. of Knesset Nov. 1965 – ; joined Unity Govt. as Minister of Defence 1967; Knesset "Maarach" (Alignment) list 1969; Minister of Defence 1969 – 74, of Foreign Affairs 1977 – 79; Independent M.P. 1977 – ; f. Nat. Unity Party 1981; Editor-in-Chief of Hayom Haze (newspaper) 1976 – . *Publications:* Diary of the Sinai Campaign 1966, Mapa Kadasha, Yahassim Aherim (New Map, Other Relations) 1969, Story of my Life 1976, Living with the Bible 1978; various articles on Viet-Nam, etc. *Leisure interest:* archaeology. Died 1981.

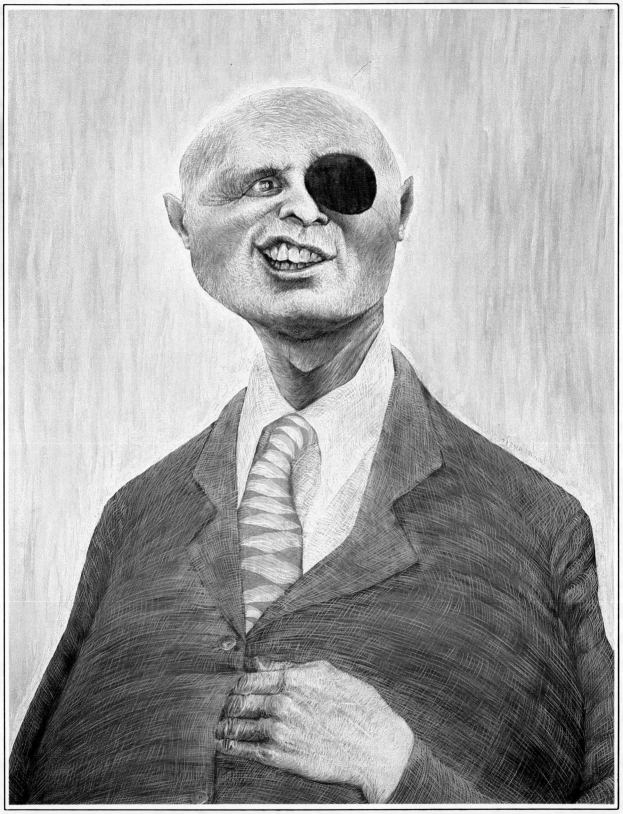

Mubarak

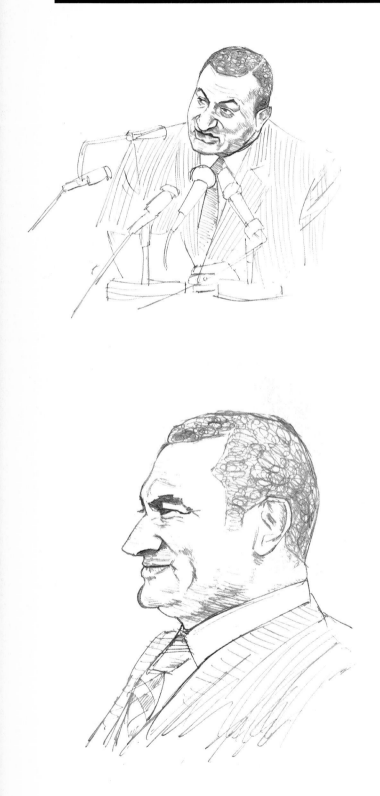

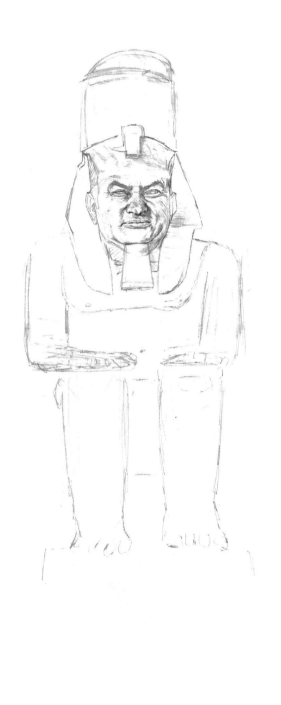

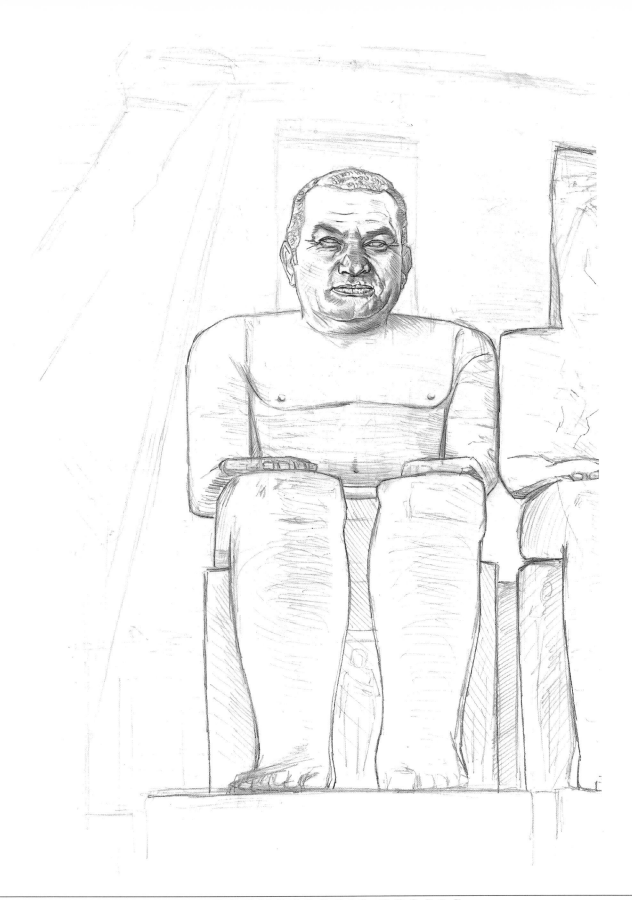

"I will do all I can to rise to the standards of President Sadat's imagination."

MUBARAK, Lt.-Gen. (Muhammad) Hosni; Egyptian air force officer and politician; b. 4 May 1928, Kafr El-Moseilha, Minuffya Governorate; ed. Mil, Acad., Air Acad.; joined Air Force 1950; Dir.-Gen. Air Acad. 1967 – 69; Air Force Chief of Staff 1969 – 72; C.-in-C. 1972 – 75; promoted to Lt.-Gen. 1973; Vice-Pres. of Egypt 1975 – 81; Vice-Chair. Nat. Democratic Party (NDP) 1976 – 81; mem. Higher Council for Nuclear Energy 1975 – ; Sec.-Gen. NDP and Political Bureau 1981 – 82, Chair. 1982 – ; Pres. of Egypt Oct. 1981 – (Cand. of NDP); Prime Minister Oct. 1981 – Jan. 1982; Order of Star of Sinai. *Address:* Presidential Palace, Abdeen, Cairo, Egypt.

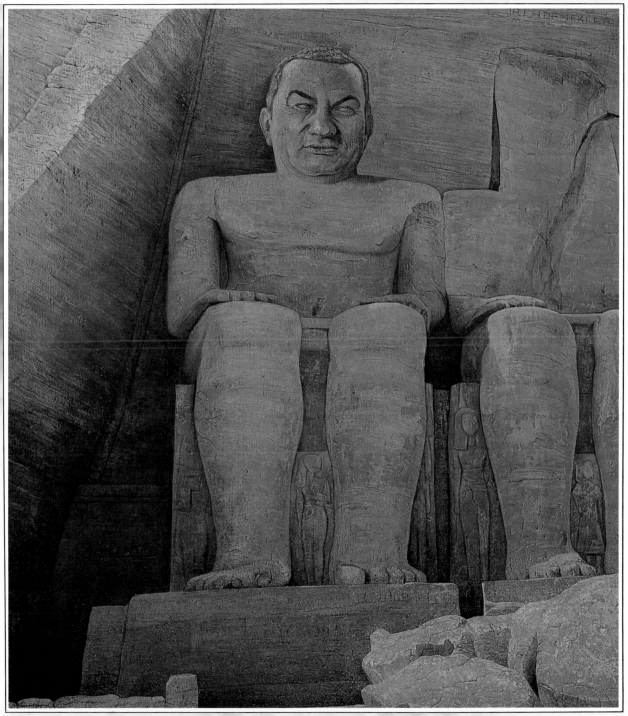

Fahd

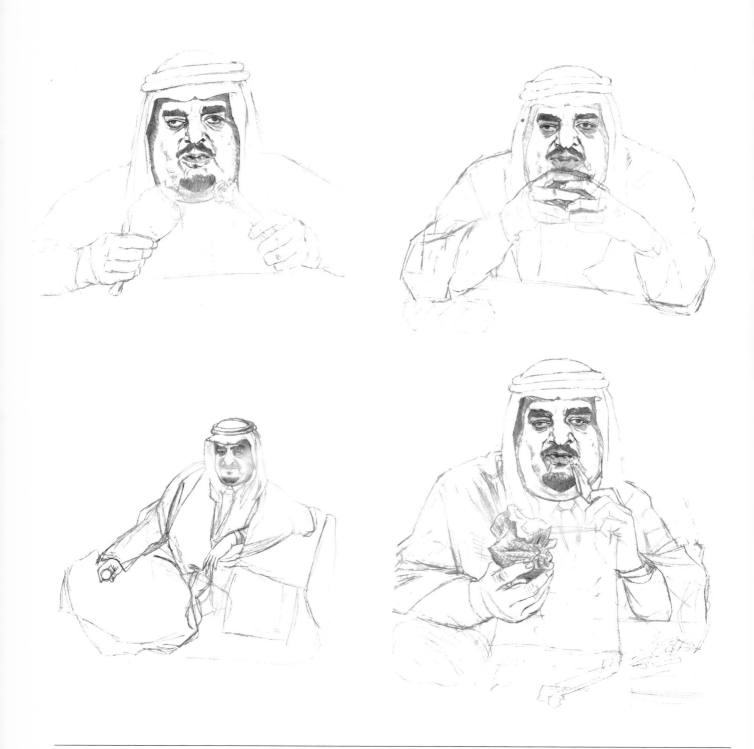

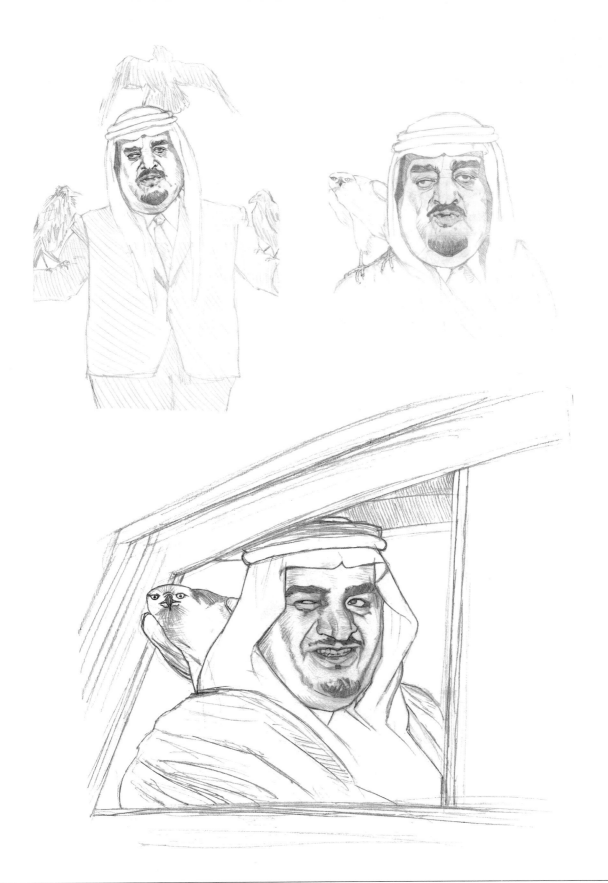

"All the masks have fallen and talk of peace has become a mere illusion."

FAHD IBN ABDUL AZIZ, Crown Prince; Saudi Arabian politician; b. 1920; brother of H.M. King Khalid (q.v.); Minister Educ. 1953, of the Interior 1962 – 1975; Second Deputy Prime Minister 1968 – 75, First Deputy Prime Minister March 1975 – ; became King Fahd June 14 1982. *Address:* Council of Ministers, Jeddah, Saudi Arabia.

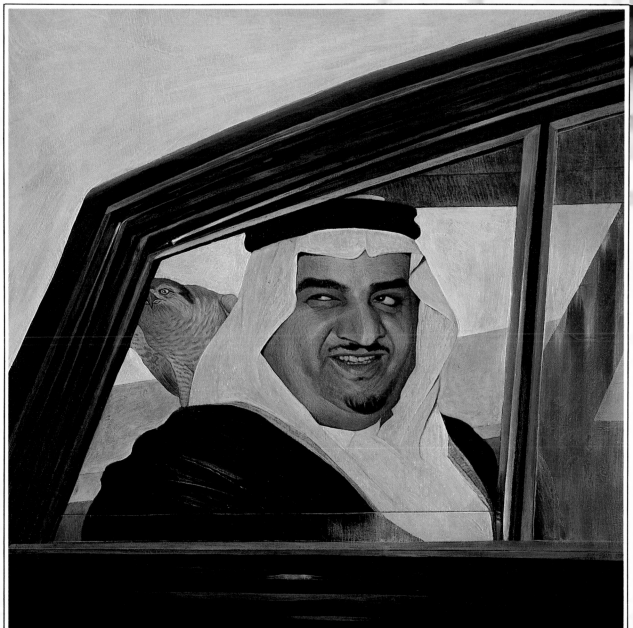

Khomeini

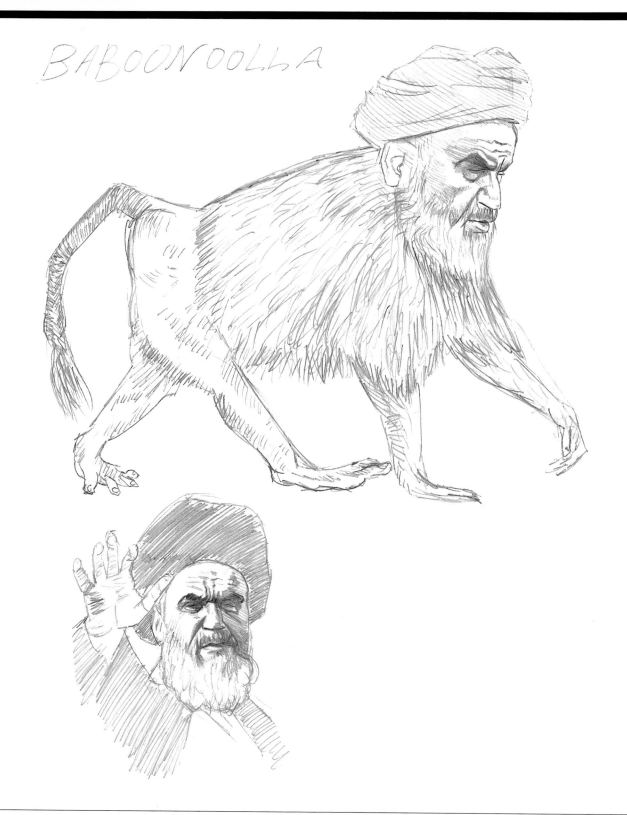

BABOONOOLLA

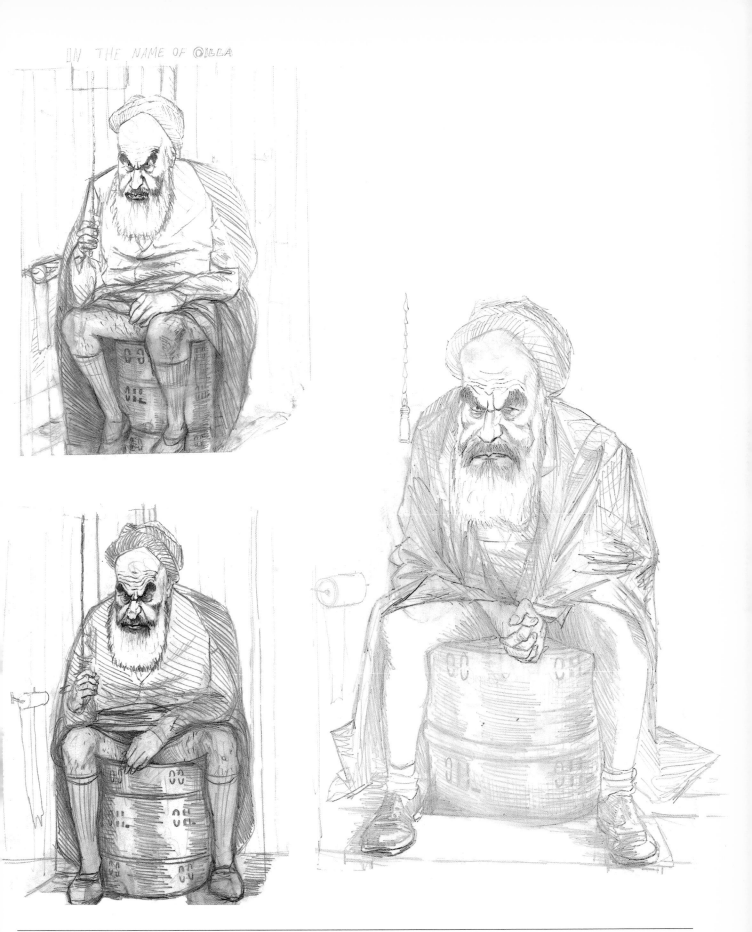

IN THE NAME OF QIBLA

"I will not sit back and advise, I'll cut everybody's hands off."

KHOMEINI, Ayatollah Ruhollah; Iranian religious leader; b. 17 May 1900, Khomein; ed. in Khomein and at theological school, Qom; religious teacher in theological school, Qom; arrested in Qom after riots over Shah's land reforms June – Aug. 1963; in exile, Turkey 1965 – 65, Najaf Iraq 1965 – 78, Neauphlé-le-Château, France Oct. 1978 – Feb. 1979; while in exile aimed to create an Islamic Republic and from France was the most powerful influence on the revolution which toppled Shah Mohammad Reza Pahlavi; returned to Iran Feb. 1979; appointed Government of Mehdi Bazargan (q.v.) after collapse of the Bakhtiar Government; returned to theological seminary, Qom, but continued as leader of Islamic movement March 1979 – ; under new constitution, became Velayat Faghih (religious leader) 1980 – . *Publications:* The Government of Theologians (lectures whilst in exile) and numerous religious and political books and tracts. *Address:* Madresseh Faizieh, Qom; 61 Kuche Yakhchal Ghazi, Qom, Iran (Home).

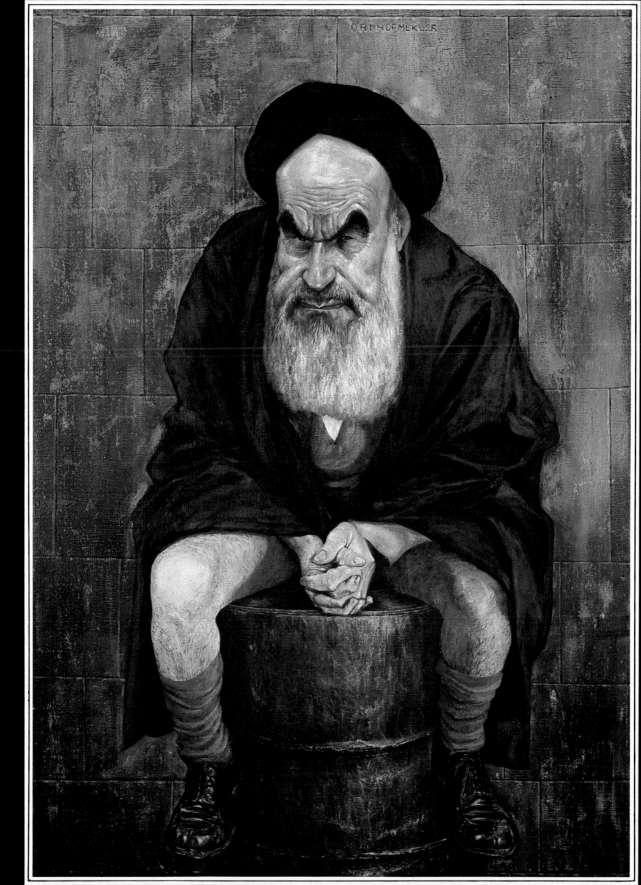

Gaddafi

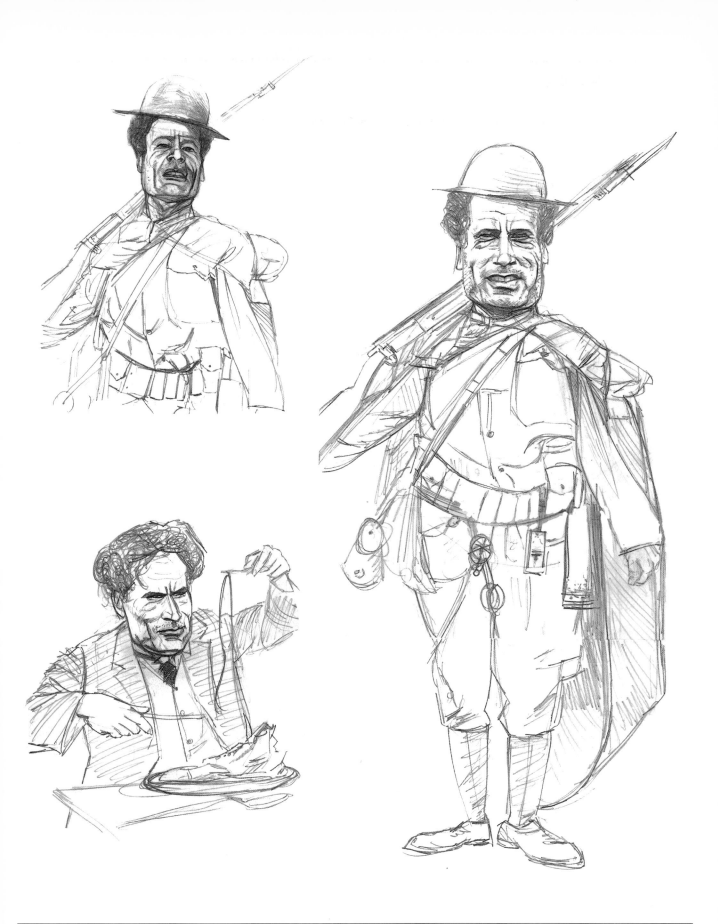

"People are getting killed everywhere by their leaders."

GADDAFI, Col. Mu'ammar Muhammad al-; Libyan army officer and political leader; b. 1942, Serte; s. of Mohamed Abdul-salam Abuminiar and Aisha Ben Niran; m. 1970; four s. one d.; ed. Univ. of Libya, Benghazi; Served with Libyan Army 1965; Chair. Revolutionary Command Council 1969 – 77; C.-in-C. of Armed Forces Sept. 1969 – ; Prime Minister 1970 – 72; Minister of Defence 1970 – 72; Pres. of Libya March 1977 – ; Sec.-Gen. of Gen. Secretariat of Gen. People's Congress 1977 – 79; mem. Pres. Council, Fed. of Arab Republics 1971 – ; rank of Maj.-Gen. Jan. 1976, still keeping title of Col. *Publications:* The Green Book (3 vols.), Military Strategy and Mobilisation, The Story of the Revolution. *Address:* Office of the President, Tripoli, Libya.

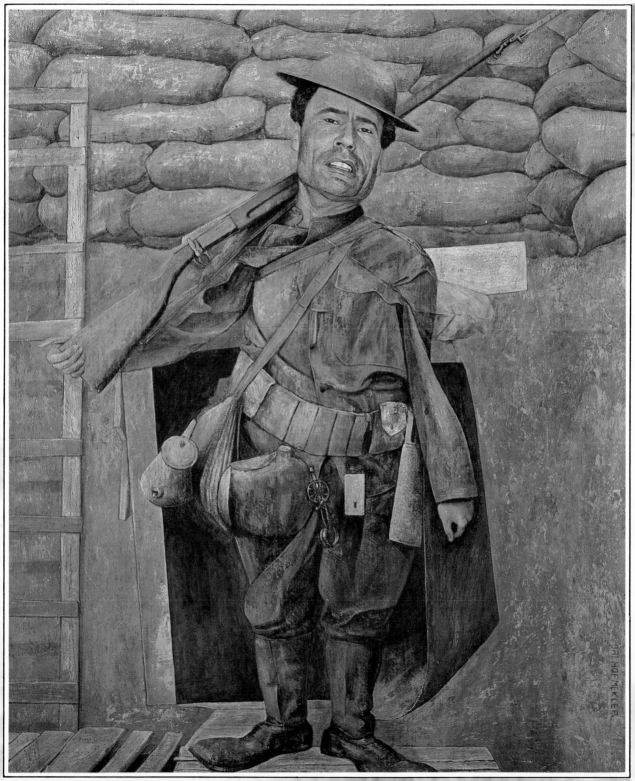

Amin

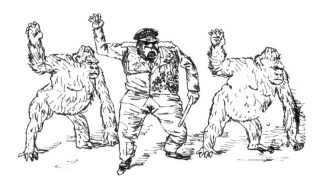

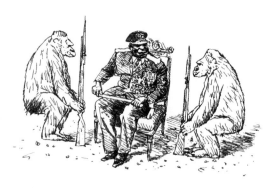

NEXT NOBEL PRICE AWARDED

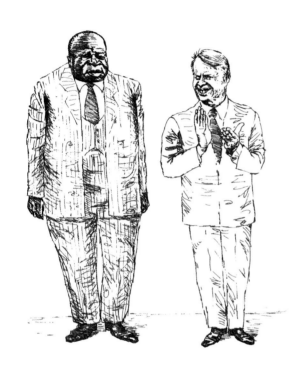

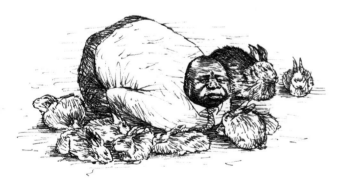

"I captured some of the people who tried to assassinate me. I ate them before they ate me."

AMIN DADA, Field-Marshal Idi; Ugandan army officer and fmr. Head of State; b. 1925, Kakwa Region, West Nile; s. of late Amin Dada; joined King's African Rifles 1946; rank of Corporal 1949, Major 1963, Col. 1964; Deputy Commdr. of the Army 1964; Commdr. of the Army and Air Force 1966 – 70; rank of Brig.-Gen. 1967, Maj.-Gen. 1968, promoted Field-Marshal July 1975; leader of mil. *coup d'état* which deposed Pres. Milton Obote Jan. 1971; Pres. and Chief of Armed Forces 1971 – 79 (Life Pres. 1976 – 79 overthrown in Tanzanian invasion, fled Uganda); Minister of Defence 1971 – 75; Chair. Defence Council 1972 – 79; Minister of Internal Affairs 1973, of Information and Broadcasting 1973, of Foreign Affairs Nov. 1974 – Jan. 1975, of Health 1977 – 79, of Foreign Affairs 1978, of Information, Broadcasting and Tourism, Game and Wildlife 1978 – 79, of Internal Affairs 1978 – 79; Chief of Staff of the Army 1974 – 79; Chair. OAU Ass. of Heads of State 1975 – 76, presided over Kampala Summit 1975, Addis Ababa Summit 1976; Heavyweight Boxing Champion of Uganda 1951 – 60; awarded eight highest mil. decorations of Uganda; Hon. LL.D. (Kampala) 1976; in exile in Jeddah, Saudi Arabia.

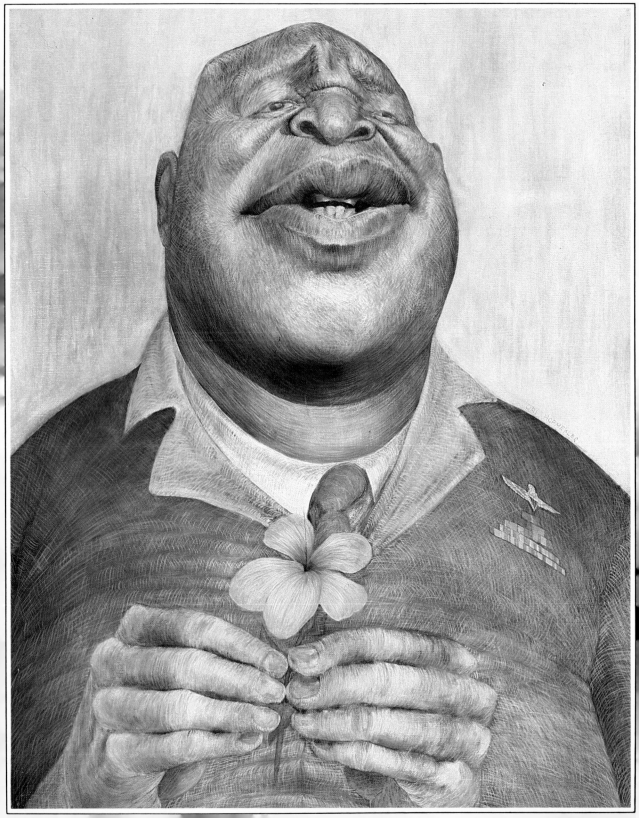

Thatcher

DARNING SHOW

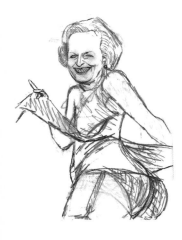

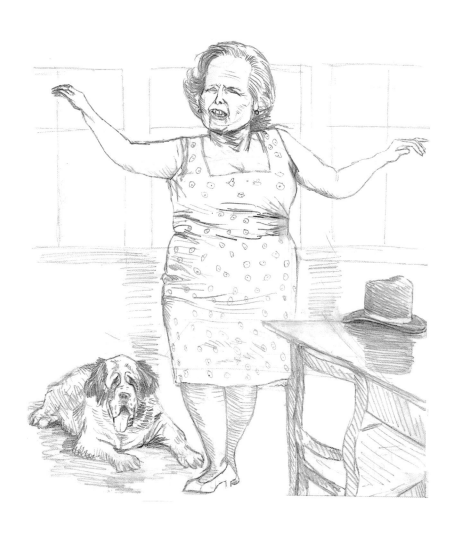

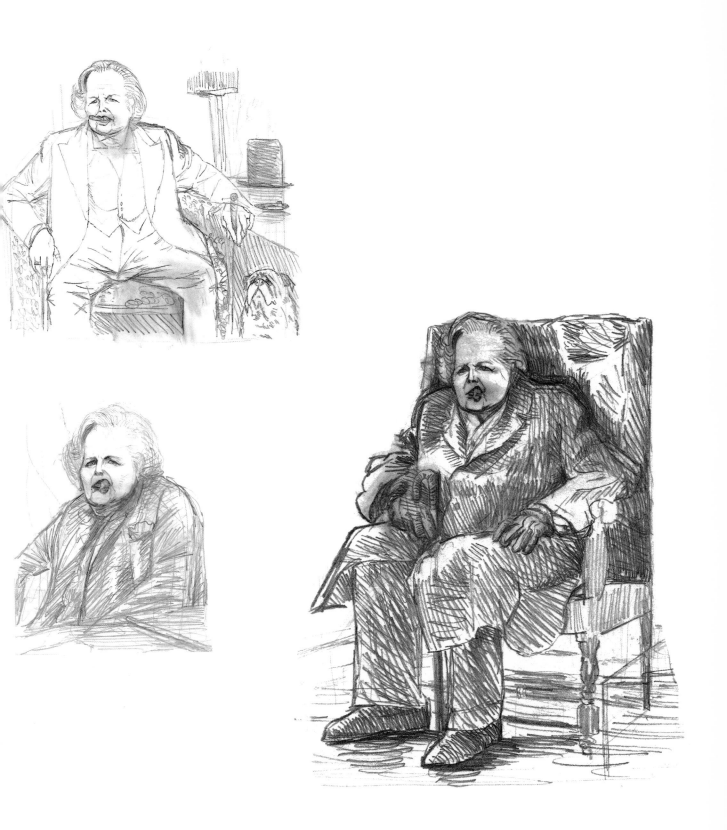

"The lady's not for turning."

THATCHER, Rt. Hon. Margaret Hilda, P.C., M.P., M.A., B.SC.; British barrister and politician; b. 13 Oct. 1925; d. of the late Alfred Roberts; m. Denis Thatcher 1951; one s. one d. (twins); ed. Grantham High School and Somerville Coll., Oxford; Research Chemist 1947 – 51; called to the Bar, Lincoln's Inn 1953; M.P. for Finchley 1959 – ; Parl. Sec. Ministry of Pensions and Nat. Insurance 1961 – 64; Chief Opposition Spokesman on Educ. 1969 – 70; Sec. of State for Educ. and Science 1970 – 74; Leader of Conservative Party Feb. 1975 – ; Leader of H.M. Opposition 1975 – 79; Prime Minister May 1979 – ; Hon. Bencher, Lincoln's Inn 1975; Hon. Fellow Royal Inst. of Chemistry 1979; Freedom of Royal Borough of Kensington and Chelsea 1979, of London Borough of Barnet 1980; Conservative *Address:* 10 Downing Street, London, S.W.1, England.

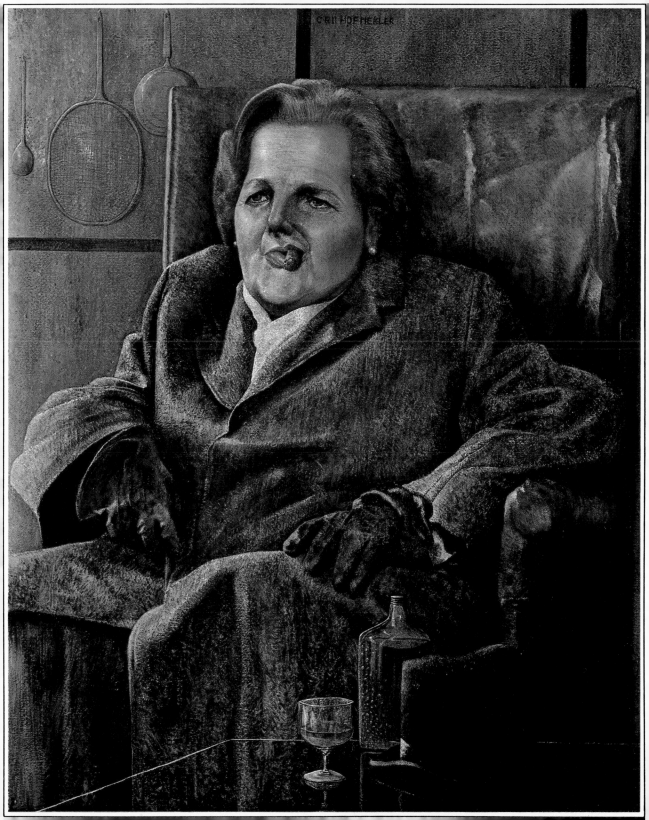

Galtieri

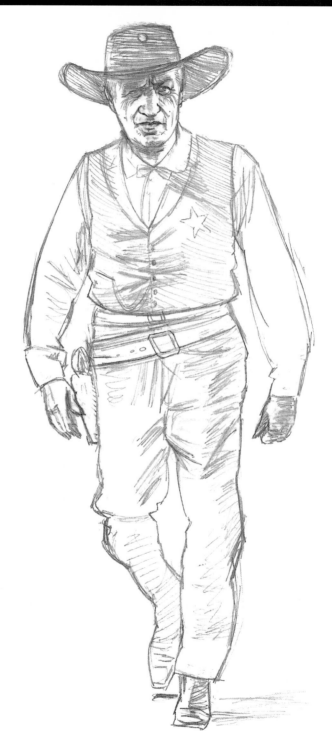

Galtieri Kid

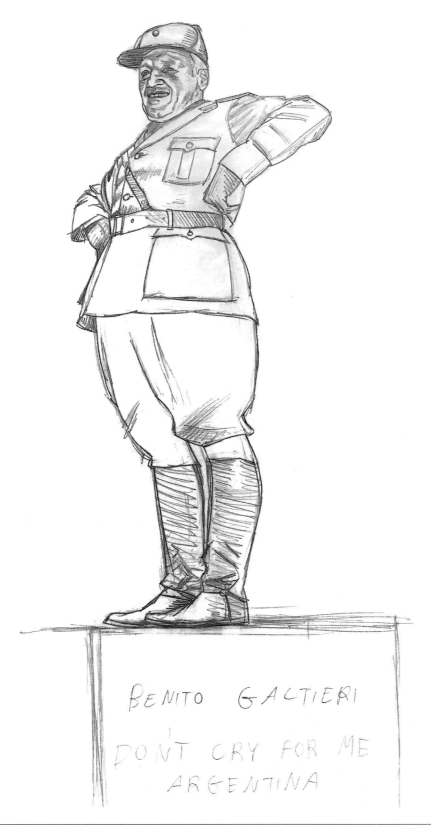

BENITO GALTIERI

DON'T CRY FOR ME
ARGENTINA

"The Argentine people, not I, I am sure, are willing to accept not only 400 deaths, but 4,000 or 40,000 more."

GALTIERI, Lieut.-Gen. Leopoldo Fortunato; Argentine army officer and politician; b. 15 July 1926, Caseros (Prov. of Buenos Aires); m. Lucia Noemi Gentili 1949; one s. two d.; ed. Buenos Aires, Nat. Mil. Coll.; Sub-Lieut., engineers 1945, Lieut. 1947, First Lieut. 1949, Capt. 1952; joined Batallon 4 de Zapadores (Sappers), 1952 – 54; became Major 1957, Infantry Div. Commdr. 1962, Lieut.-Col.; Prof. at Escuela Superior de Guerra 1962; Sub.-Dir. Engineers' Training School 1964 – 67; promoted Col. 1967, Brig.-Gen. commanding 9th Infantry Brigade 1972 – 73, 7th Brigade 1974 – 75; Major-Gen. 1975; Deputy Chief of Staff 1975; Commdr. 2nd Army Corps 1976, 1st Army Corps Jan.-Dec. 1979; Lieut-Gen. and C.-in-C. of the Army Dec. 1979 – ; also mem. ruling military junta Dec. 1979 – ; Pres. of Argentina 1981 – 1982; seized Falkland Isles April 1982; numerous military decorations. *Address:* unknown

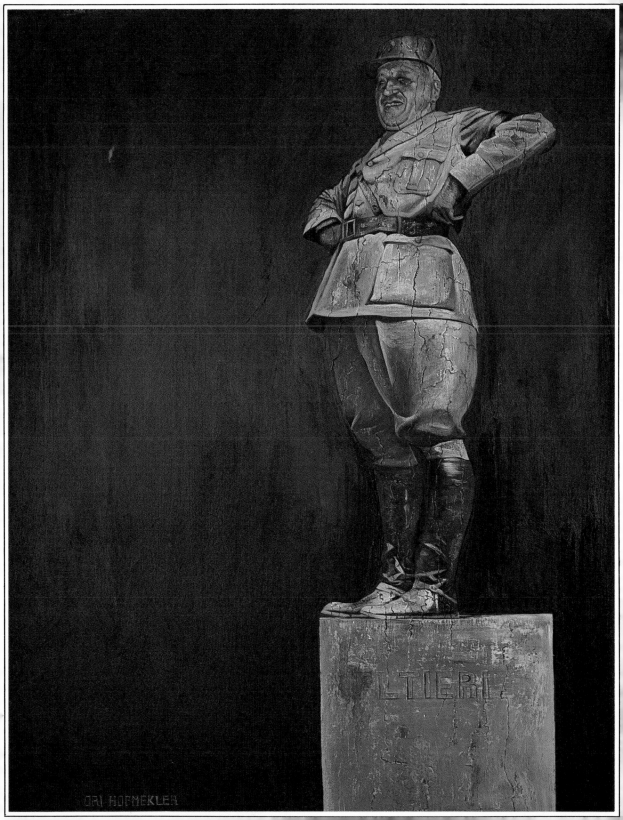

Schmidt

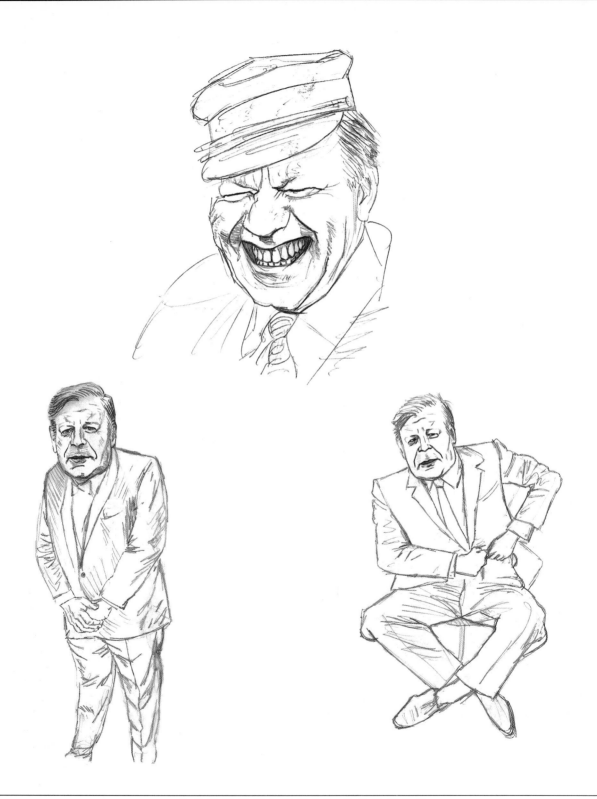

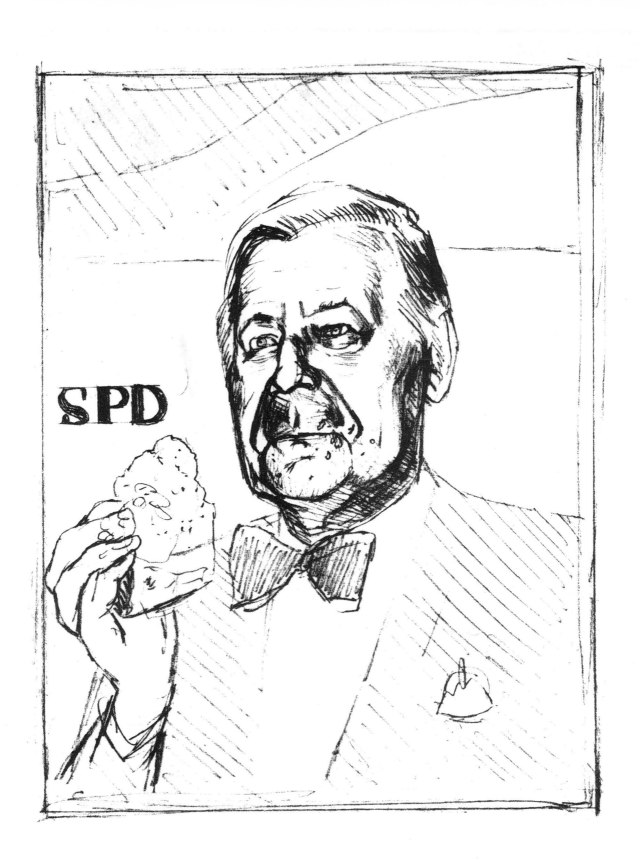

"We do have some family problems."

SCHMIDT, Helmut, German economist and politician; b. 23 Dec. 1918 Hamburg; s. of Gustav and Ludovica Schmidt; m. Hannelore Glaser 1942; one d.; ed. Lichtwarkschule and Univ. Hamburg; Man. Transport Admin. of State of Hamburg 1949 – 53; mem. Social Democrat Party 1946 – ; mem. Bundestag 1953 – 62, 1965 – ; Chair. Social Democrat (SPD) Parl. Party in Bundestag 1967 – 69; Vice-Chair. SPD 1968 – ; Senator (Minister) for Domestic Affairs in Hamburg 1961 – 65; Minister of Defence 1969 – 72, for Econ. and Finance July-Dec. 1972, of Finance 1972 – 74; Fed. Chancellor May 1974 – Sept. 1982 ; Dr. Iur. h.c. (Newberry Coll.) 1973, (Johns Hopkins Univ.) 1976, (Harvard Univ.) 1979, Hon. D.C.L. (Oxford) 1979, Hon. Dr. (Sorbonne Univ.) 1981; European Prize for Statesmanship (F.U.S. Foundation) 1979; Nahum Goldmann Silver medal 1980. *Publications:* Defence or Retaliation 1962, Beitrage 1967, Strategie des Gleichgewichts 1969 (English edition "Balance of Power" 1970), Auf dem Fundament des Godesberger Programms 1973, Bundestagsreden (2nd edition) 1975, Kontinuitat und Konzentration (2nd edition) 1976, Als Christ in der politischen Entscheidung 1976.

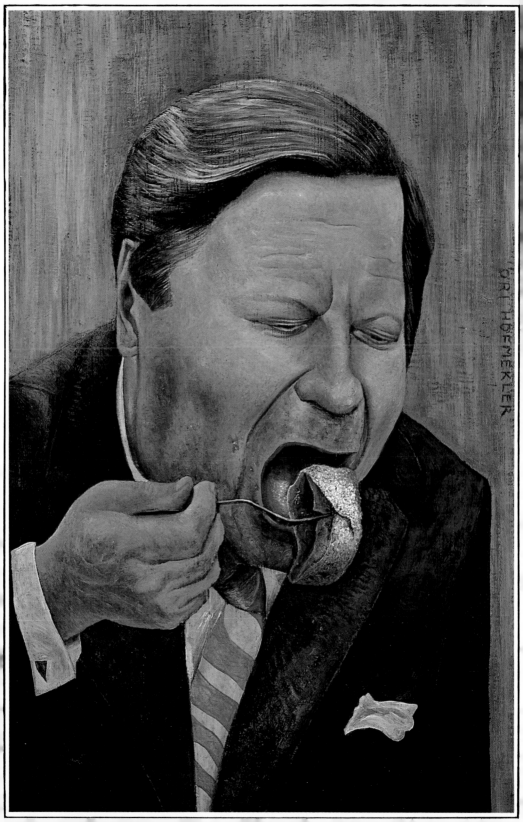

Strauss

"God is no socialist. He created men differently."

STRAUSS, Franz Josef; German politician; b. 6 Sept. 1915, Munich; m. Marianne Zwicknagl 1957; two s. one d.; ed. Univ. of Munich; served Second World War 1939 – 45; mem. Bavarian Christian Social Union Party (C.S.U.) 1945 – , Deputy Chair. 1952, Chair. 1961 – ; mem. Bundestag (Fed.Parl) 1949 – 78; Fed. Minister-at-Large 1953 – 55, of Nuclear Energy 1955 – 56, of Defence 1956 – 62, of Finance 1966 – 69; Prime Minister of Bavaria Nov. 1978 – ; Leader of CDU/CSU parties 1979 – 80. *Publications:* The Grand Design 1965, Herausforderung und Antwort 1968, Finanzpolitik, Theorie und Wirklichkeit 1968, Bundestagsreden 1968, 1974 and 1979, Deutschland Deine Zukunft 1975, Signale 1978, Zur Lage 1979, Gebote fur die Politik der Freiheit 1980. *Leisure interests:* reading, sports. *Address:* Bayer. Staatskanzlei, Prinzregentenstrasse 7, Munich 22; Nymphenburgerstrasse 64, Munich 19, Federal Republic of Germany. *Telephone:* 2165-215; 1243-215.

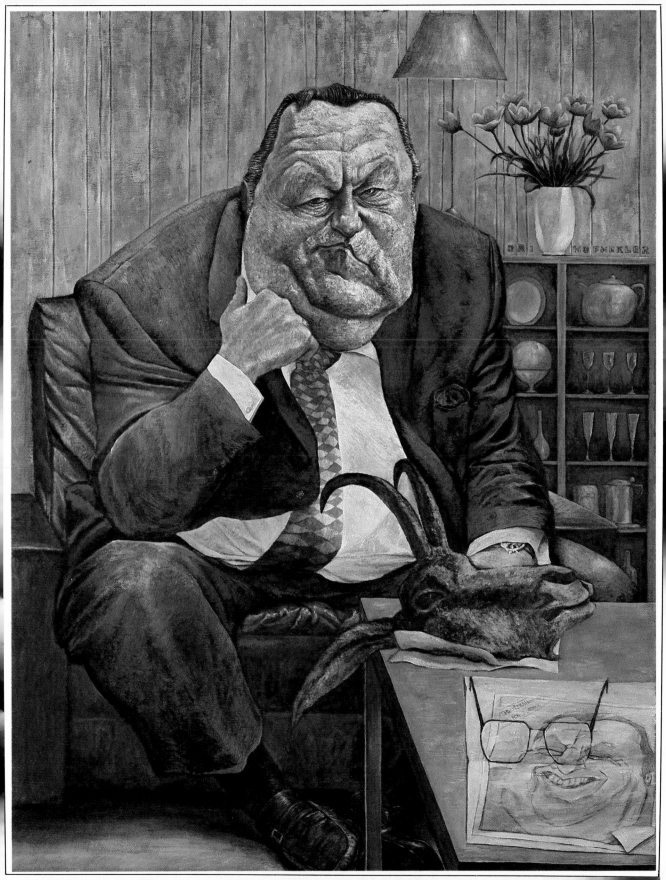

Mitterrand

"I am no longer the socialist candidate, nor am I the candidate of the left, I am from here on, the candidate of the mobilization of Frenchmen."

MITTERRAND, François Maurice Marie; French politician; b. 26 Oct. 1916; s. of Joseph and Yvonne (née Lorrain) Mitterrand; brother of Gen. Jacques Mitterrand (q.v.); m. Danielle Gouze 1944; two s.; ed. Univ. of Paris; served 1939 – 40; taken prisoner, escaped back to France where active in P.O.W. and resistance movements; missions to London and Algiers 1943; Sec.-Gen. Org. for P.O.W.s, War Victims and Refugees 1944 – 46; elected Deputy for Nièvre, Nat. Assembly 1946, 1962, 1967, 1968, 1973, 1978; Conseiller Général, Montsauche Dist. 1949; Minister for Ex-Servicemen 1947 – 48; Sec. of State for Information attached Prime Minister's Office 1948 – 49; Minister for Overseas Territories 1950 – 51; Chair. Union Démocratique et Socialiste de la Résistance 1951 – 52; Minister of State Jan. -Feb. 1952, March 1952 – July 1953; Del. to Council of Europe July-Sept. 1953; Minister of the Interior 1954 – 55; Minister of State for Justice 1956 – 57; Mayor of Château-Chinon 1959; Senator 1959 – 62; Pres. of Fed. of Democratic and Socialist Left 1965 – 68; First Sec. Socialist Party 1971 – ; Vice-Chair. The Socialist Int. 1972 – ; Cand. for Pres. of France 1965, 1974; Pres. of France 1981 – ; Pres., Dir.-Gen. Soc. D'Editions modernes parisiennes 1945 – 57; Officier, Légion d'honneur, Croix de guerre, Rosette de la Résistance. *Publications:* Aux frontières de l'union française, La Chine au défi 1961, Le coup d'état permanent 1964, Technique économique française 1968, Ma part de vérité 1969, Un socialisme du possible 1971, La rose au poing 1973, La paille et le grain 1975, Politique 1977, L'abeille et l'architecte 1978, Ici et maintenant 1980. *Address:* Palais de l'Elysée, 55 – 57 rue du Faubourg Saint-Honoré, 75008 Paris, France.

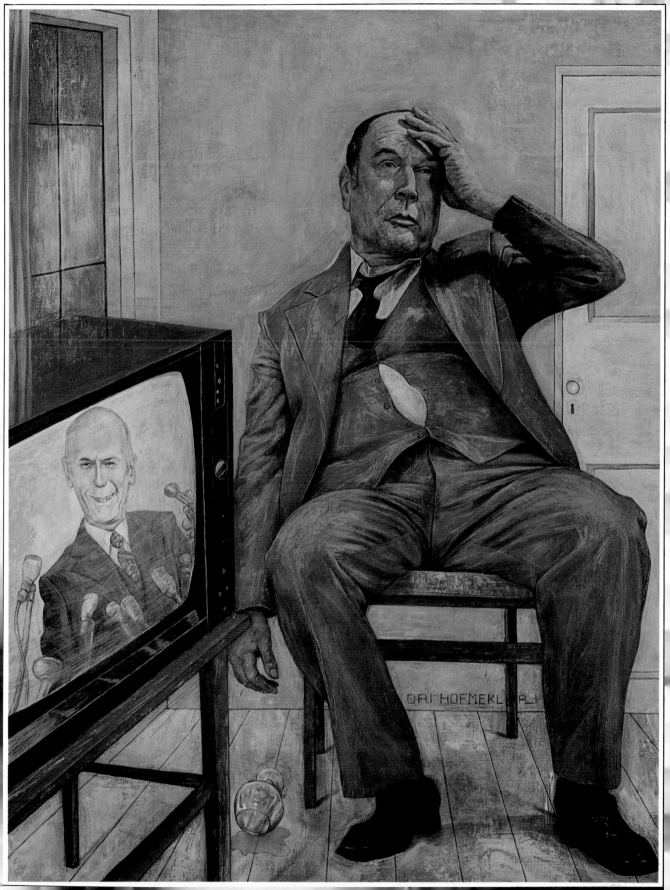

ORI HOFMEKLER

Georges Marchais and les Companions

"Politics is like a cut flower, easily withered."

MARCHAIS, Georges; French politician; b. 7 June 1920, La Hoquette; s. of René and Germaine (née Boscher) Marchais; m. 1st Paulette Noetinger 1941 (divorced); three c; m. 2nd Liliane Garcia Marchais; one s.; fmr. metal worker; active in trade union movt.; joined French CP 1947, mem. Cen. Cttee. 1956, mem. Political Bureau 1959, Sec. Cen. Cttee. 1961, Sec.-Gen. Dec. 1972 – ; elected Deputy for Val-de-Marne, Nat. Assembly 1973, 1978; mem. European Parl. 1979 – . *Publications:* Qu'est-ce que le parti communiste français? 1970, Les communistes et les paysans (co-author) 1972, Le défi démocratique 1973, La politique du parti communiste français 1974, Parlons franchement 1977, Réponses 1977. *Address:* Parti Communiste

Français, 2 Place du Colonel Fabien, 75019 Paris, France. *Telephone:* 202-70-10.

CHIRAC, Jacques René; French politician; b. 29 Nov. 1932, Paris; s. of François Chirac and Marie-Louise Valette; m. Bernadette Chodron de Courcel 1956; two c.; ed. Lycée Carnot, Lycée Louis-le-Grand and Ecole Nationale d'Administration; Military Service in Algeria; Auditor, Cour des Comptes 1959-62; Head of Dept., Sec.-Gen. of Govt. 1962; Head of Dept., Private Office of M. Pompidou 1962-65; Counsellor, Cour des Comptes 1965-67; Sec. of State for Employment Problems 1967-68; Sec. of State for Economy and Finance 1968-71; Minister for Parl.

Relations 1971-72, for Agriculture and Rural Devt. 1972-74, of the Interior March-May 1974; Prime Minister 1974-76; Sec.-Gen. Union des Démocrates pour la République (UDR) Jan.-June 1975, Hon. Sec.-Gen. 1975-76; Pres. Rassemblement pour la République (fmrly. UDR) Dec. 1976, Hon. Sec.-Gen. 1977-80, Pres. 1980-81, 1982-; elected to Nat. Assembly 1967, 1968, 1973, 1976, 1978; mem. European Parl. 1979; Counsellor-Gen., Meyrac 1968, 1970; Pres. Gen. Council, La Corrèze 1970-79; Municipal Counsellor, Sainte-Féréole 1965-; Mayor of Paris March 1977-; Grand Croix, Ordre nat. du Mérite, Chevalier du Mérite agricole, des Arts et des Lettres, etc. *Address:* 110 rue du Bac, 75007, Paris, France.

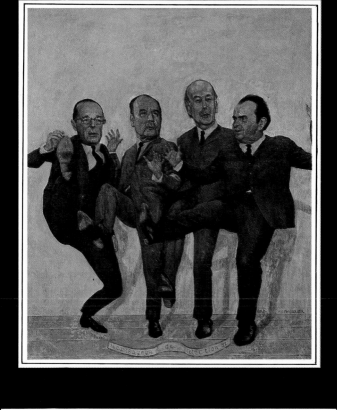

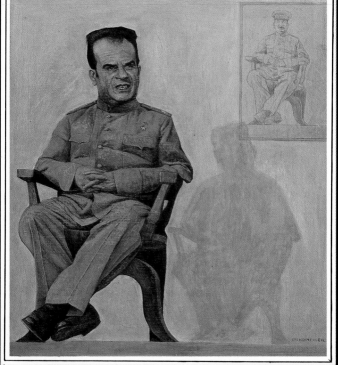

Giscard d'Estaing

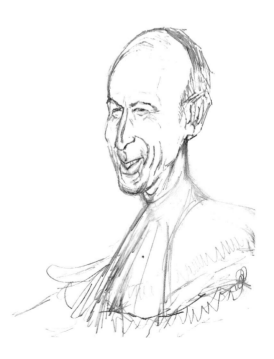

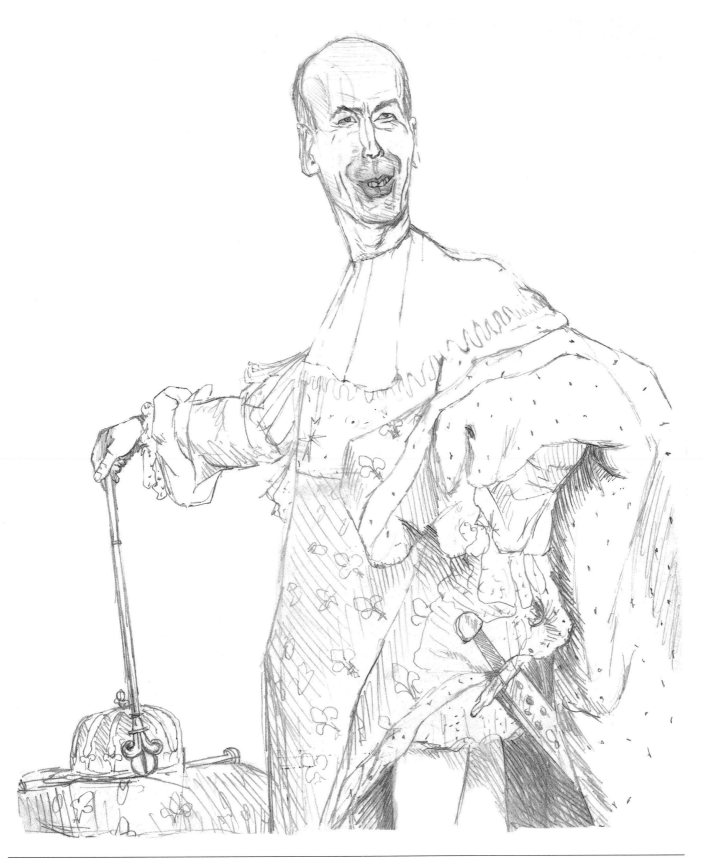

"I believe I have done everything I could to explain to French women and men the meaning and the consequences of their choice."

GISCARD D'ESTAING, Valéry, K.C.B.; French politician and civil servant; b. 2 Feb. 1926, Koblenz, Germany; s. of Edmond Giscard D'Estaing (q.v.) and May Bardoux; m. Anne-Aymone de Brantes 1952; two s. two d.; ed. Ecole Polytechnique, Ecole Nat. d'Admin.; Official, Inspection des Finances 1952, Insp. 1954; Deputy Dir. du Cabinet of Prés. du Conseil June-Dec. 1954; Deputy for Puy de Dôme 1956 – 58, re-elected for Clermont 1958, for Puy du Dôme 1962, 1967; Sec. of State for Finance 1959, Minister for Finance and Econ. Affairs 1962 – 66, 1969 – 74; Pres. Comm. des Finances, de l'Economie général et du plan 1967 – 68; Pres. of France 1974 – 81; Founder-Pres. Fed. Nat. des Républicains, Indépendants (from May 1977 Parti Républicain) 1965; Del. to UN Gen. Assembly 1956, 1957, 1958; Chair. OECD Ministe-rial council 1960; Grand Maitre Ordre de la Legion d'honneur, Grand Maitre, Ordre national du Mérite, Croix de guerre, Chevalier, Ordre de Malte, Grand Cross, Order of Isabel la Catolica, Nansen Medal 1979, etc. *Publication:* La démocratie française 1976. *Leisure interests:* shooting, skiing. *Address:* Varvasse, Chanonat (Puy de Dôme), France.

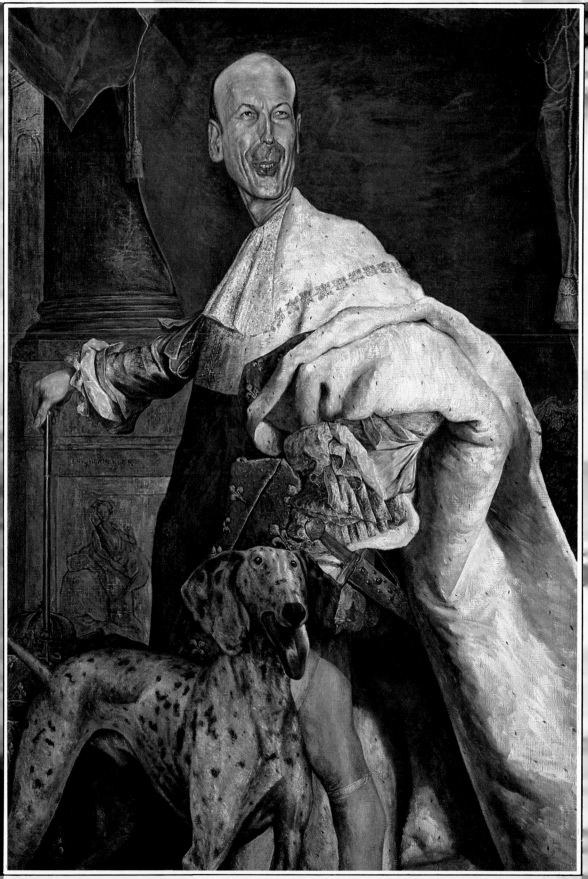

John Paul II

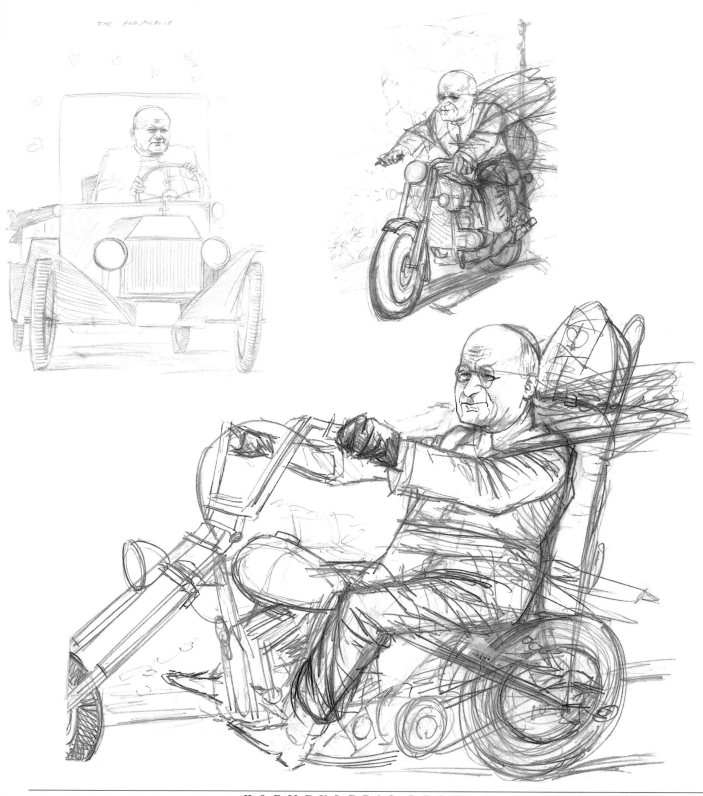

THE POPEMOBILE

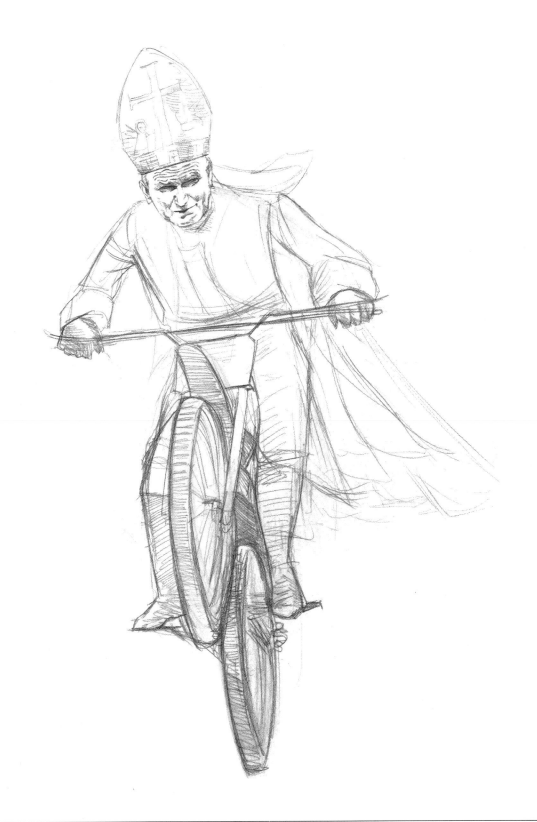

"Your profession as chauffeurs should remind you continually that we are all on the road heading at high speed toward eternity."

John Paul II, His Holiness Pope (Karol Wojtyla); b. 18 May 1920, Wadowice; ed. Jagiellonian Univ., Cracow; ordained Priest 1946; Prof. of Moral Theology at Univs. of Cracow and Lublin; 1953-58; Chair. Dept. of Ethics, Catholic Univ., Lublin; Titular Bishop of Ombi and Vicar-General of Archdiocese 1958, Scholastic of Metropolitan Chapter and Vicar of Archdiocese 1960 – 64; Archbishop of Cracow 1963 – 78; cr. Cardinal by Pope Paul VI 1967; elected Pope Oct. 1978, Hon. Freeman of Dublin 1979. *Publications:* Love and Responsibility 1960, 1962, 1965, 1968, 1969, Person and Act 1969, The Foundations of Renewal—study of the realization of the Second Vatican Council 1972, The Acting Person 1978, Easter Vigil and Other Poems 1978, Signs of Contradiction 1980; *Plays:* The Jeweller's Shop 1960, Brothers of Our Lord 1979. *Leisure interests:* skiing, rowing, sport. *Address:* Apostolic Palace, Vatican City.

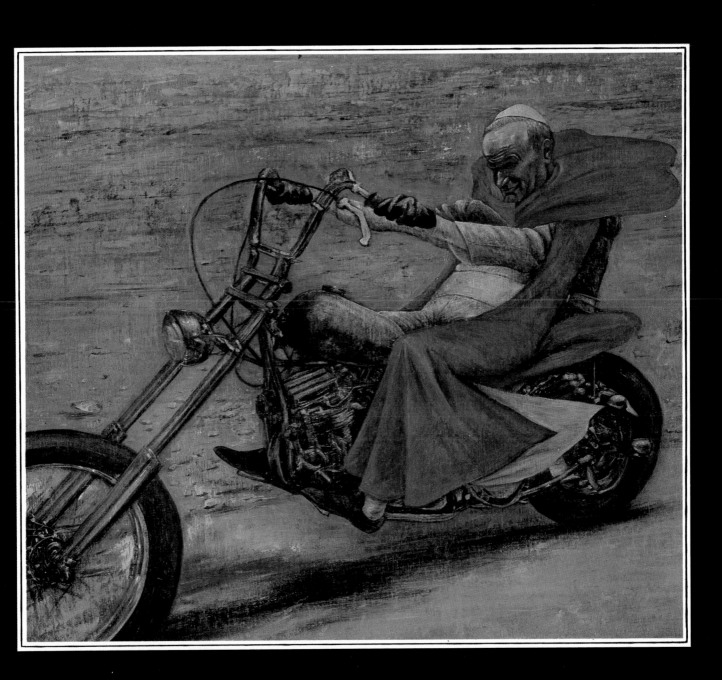

John Paul II and Friends

"Pray for encouragement, hope and fraternity."

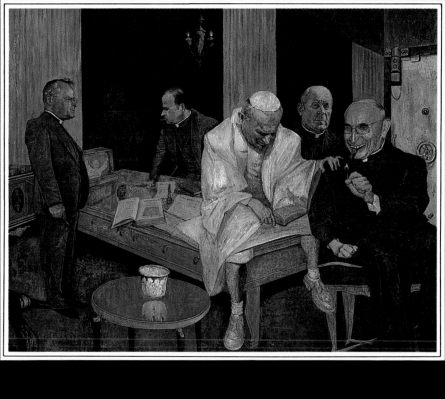

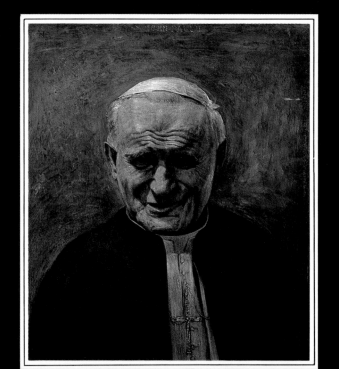

Charles and Diana

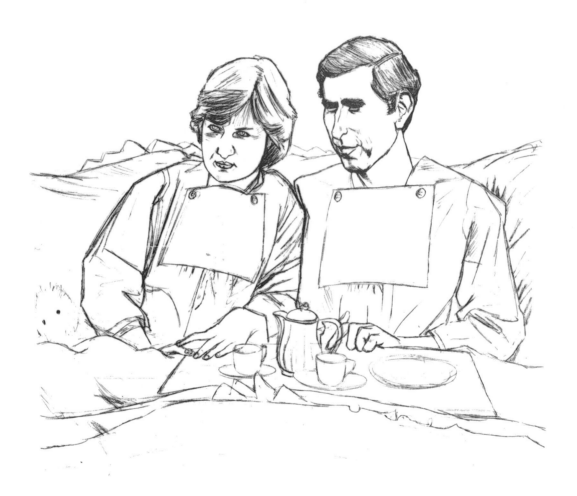

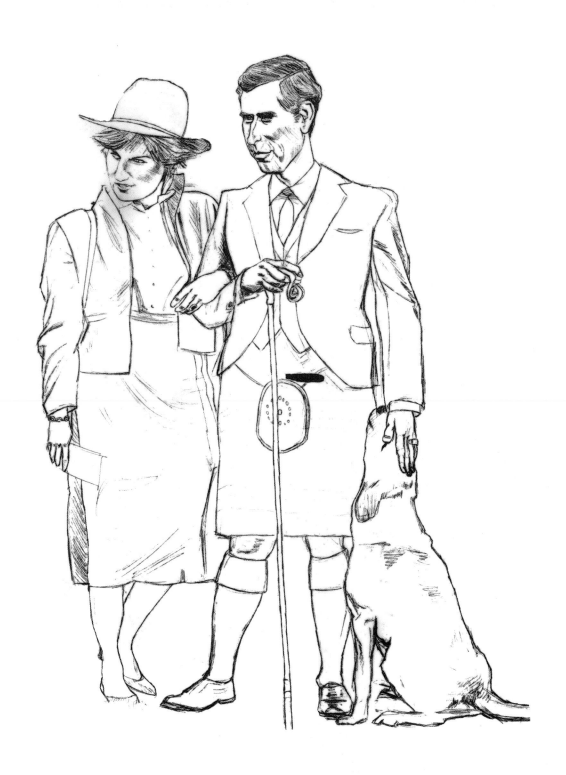

"I couldn't have married anyone the British people wouldn't have liked."

WALES, H.R.H. The Prince of, and Earl of Chester (cr. 1958); **Prince Charles Philip Arthur George**, K.G., K.T., P.C., G.C.B., M.A., Duke of Cornwall and Rothesay, Earl of Carrick, Baron of Renfrew, Lord of the Isles and Great Steward of Scotland (cr. 1952); b. 14 Nov. 1948, London; eldest son of Princess Elizabeth (now H.M. Queen Elizabeth II, q.v.) and Prince Philip, Duke of Edinburgh (q.v.); m. Lady Diana Spencer (now H.R.H. The Princess of Wales, q.v.) 29 July 1981; ed. Cheam School, Gordonstoun School, Geelong Grammar School, Trinity Coll., Cambridge, and Univ. Coll. of Wales, Aberystwyth; Barrister, Gray's Inn 1974, Hon. Bencher 1975; Personal A.D.C. to H.M. the Queen 1973 – ; Commdr. R.N. 1976 – ; Col.-in-Chief The Royal Regt. of Wales (24th/41st Foot) 1969 – ; Col. Welsh Guards 1974 – ; Col.-in-Chief The Cheshire Regt. 1977 – , The Gordon Highlanders 1977 – , Lord Strathcona's Horse (Royal Canadian) Regt. 1977 – , The Parachute Regt. 1977 – , The Royal Australian Armoured Corps 1977 – , The Royal Regt. of Canada 1977 – , 2nd King Edward VII Own Goorkhas 1977 – , The Royal Winnipeg Rifles 1977 – ; Wing. Commdr. R.A.F. 1976 – ; Hon. Air Cdre. R.A.F. Brawdy 1977 – ; Air Cdre. in Chief R.N.Z.A.F. 1977 – ; Col.-in-Chief Air Reserves Group of Air Command in Canada 1977 – ; Pres. Soc. of St. George's and Descendants of Knights of the Garter 1975 – ; Dr. h.c. (Royal Coll. of Music) 1981; Cdr. Royal Thames Yacht Club 1974 – ; High Steward, Royal Borough of Windsor and Maidenhead 1974 – ; Chair. Queen's Silver Jubilee Trust 1978 – ; The Mountbatten Memorial Trust 1979 – ; Pres. United World Colls. 1978 – ; Chair. The Prince of Wales' Cttee. for Wales 1971 – ; Pres. The Prince's Trust 1975 – ; Chancellor, Univ. of Wales 1976 – mem. Bd. Commonwealth Devt. Corpn. 1979; represented H.M. the Queen at Independence Celebrations in Fiji 1970, at Requiem Mass for Gen. Charles de Gaulle 1970, at Bahamas Independence Celebrations 1973, at Papua New Guinea Independence Celebrations 1975, at Coronation of King of Nepal 1975, at funeral of Sir Robert Menzies 1978, at funeral of Jomo Kenyatta 1978; Coronation Medal 1953, The Queen's Silver Jubilee Medal 1977, Grand Cross of The Southern Cross of Brazil 1978, Grand Cross of The White Rose of Finland 1969, Grand Cordon of the Supreme of the Chrysanthemum of Japan 1971, Grand Cross of The House of Orange of the Netherlands 1972, Grand Cross order of Oak Crown of Luxembourg 1972, Knight of The Order of Elephant of Denmark 1974, Grand Cross of The Order of Ojasvi Rajanya of Nepal 1975, Order of the Repub. of Egypt (First Class) 1981; cr. Prince of Wales and Earl of Chester (invested July 1969); K.G. 1958 (invested and installed 1968), K.T. 1977, P.C. 1977, G.C.B. and Great Master of Order of the Bath 1975; Royal Fellowship of the Austrialian Acad. of Science 1979; Hon. Fellowship of Royal Coll. of Surgeons 1978, Royal Aeronautical Soc. 1978, Inst. of Mechanical Engineers 1979; received Freedom of City of Cardiff 1969, of Royal Borough of New Windsor 1970, of City of London 1971, of Chester 1973, of City of Canterbury 1978, City of Portsmouth 1979; Liveryman of Fishmongers' Co. 1971; Freeman of Drapers' Co. 1971; Freeman of Shipwrights' Co. 1978; Hon. Freeman and Liveryman of Goldsmiths Co. 1979; Hon. mem. of Hon. Co. of Master Mariners 1977, of Merchants of City of Edinburgh 1979. *Publication:* The Old Man of Lochnagar 1980. *Address:* Kensington Palace, London, W.8; Highgrove House, Doughton, Nr. Tetbury, Gloucs., England.

WALES, H.R.H. The Princess of; b. (as Diana Frances Spencer) 1 July 1961, Sandringham, Norfolk; d. of 8th Earl Spencer and Countess Spencer (née Frances Roche, now Hon. Mrs. Peter Shand Kydd); m. H.R.H. The Prince of Wales (q.v.) 29 July 1981; ed. Riddlesworth Hall Preparatory School, Diss, West Heath School, Sevenoaks; Teacher Young England Kindergarten School, Pimlico, London 1979 – 81. *Address:* Kensington Palace, London, W8; Highgrove House, Doughton, Nr. Tetbury, Gloucs., England.

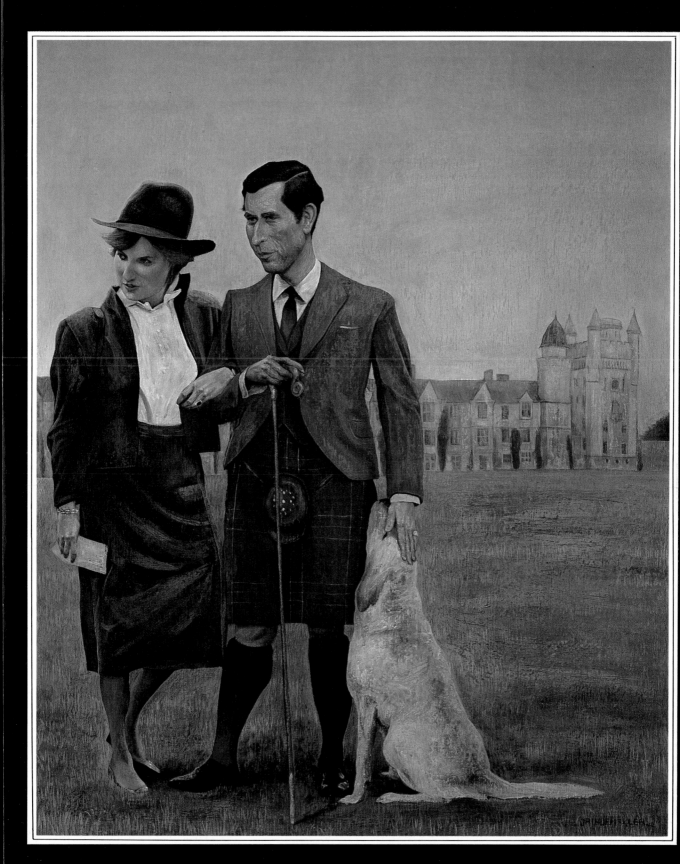

Buckingham Dallas

"My family and I..."

MARGARET ROSE, H.R.H. The Princess, Countess of Snowdon, C.I., G.C.V.O., G.C.STJ; b. 21 Aug. 1930, Glamis Castle, Angus, Scotland; sister of H.M. Queen Elizabeth II; married Antony Armstrong-Jones (now 1st Earl of Snowdon, q.v.) 1960, (divorced 1978); son, Viscount Linley, b. 1961; daughter, Lady Sarah Frances Elizabeth, b. 1964; Chancellor, Univ. of Keele; Pres. Royal Ballet; Grand Cross Order Crown of Belgium; Hon. D.Mus. (London), Hon. LL.D. (Keele). *Address:* 10 Kensington Palace, London, W8 4PU, England.

EDINBURGH, H.R.H. The Prince Philip, Duke of, Earl of Merioneth and Baron Greenwich of Greenwich in the County of London (all titles cr. 1947), created Prince of the United Kingdom of Great Britain and Northern Ireland 1957, K.G., K.T., O.M., G.B.E.; b. 10 June 1921, Corfu; s. of H.R.H. the late Prince Andrew of Greece and Denmark, G.C.V.O. and of H.R.H. the late Princess (Victoria) Alice Elizabeth Julia Marie, R.R.C., elder d. of 1st Marquess of Milford Haven, G.C.B., G.C.V.O., K.C.M.G.; ed. Cheam School, Salem (Baden), Gordonstoun School and Royal Naval Coll., Dartmouth; served 1939 – 45 war with Mediterranean Fleet in Home Waters and with British Pacific Fleet in S.E. Asia and Pacific; renounced right of succession to the Thrones of Greece and Denmark and was naturalized a British subject 1947, adopting the surname of Mountbatten; m. 20 Nov. 1947 H.R.H. Princess Elizabeth (now H.M. Queen Elizabeth II), elder daughter of H.M. King George VI; Personal A.D.C. to H.M. King George VI 1948 – 52; P.C. 1951 – ; Chancellor, Univ. of Wales 1948 – 76, Univ. of Edinburgh 1952 – , Univ. of Cambridge 1977 – , Salford Univ.; Admiral of the Fleet, F.M. and Marshal of the R.A.F. 1953 – , of R.N.Z.A.F. 1978, Marshal of N.Z. Army 1978; Patron and Chair. of Trustees, Duke of Edinburgh's Award Scheme 1956 – ; P.C. of Canada 1957 – ; Visitor, R.C.A. 1967 – ; Pres. numerous bodies, including English-Speaking Union of the Commonwealth 1952 – ; R.S.A. 1952 – ; Commonwealth Games Federation 1955 – , Royal Agricultural Soc. of the Commonwealth 1958 – ; B.M.A. 1959 – 60, Wildlife Trust 1960 – 65, 1972 – 77, World Wildlife Fund British Nat. Appeal 1961 – , Council for Nat. Academic Awards 1965 – 75, Scottish Icelandic Asscn. 1965 – , The Maritime Trust 1969 – 79, Nat. Council of Social Service 1970 – 73, Australian Conservation Foundation 1971 – 76, David Davies Memorial Inst. of Int. Studies 1979 – , World Wildlife Fund Int. 1981 – ; Hon. LL.D. (Wales, London, Edinburgh, Cambridge, Karachi and Malta), Hon. D.C.L. (Durham and Oxford), Hon. D.Sc. (Delhi, Reading, Salford, Southampton and Victoria), Hon. Degree (Eng. Univ., Lima, Peru); Hon. Dr. of Law (Univ. of Calif. at Los Angeles), numerous awards and decorations from many countries. *Publications:* Birds from Britannia 1962, Wildlife Crisis (with late James Fisher) 1970, The Environmental Revolution: Speeches on Conservation 1962 – 77 1978. *Address:* Buckingham Palace, London, S.W.1, England.

ELIZABETH II (Elizabeth Alexandra Mary); Queen of Great Britain and Northern Ireland and of her other Realms and Territories (see under Reigning Royal Families at front of book for full titles); b. 21 April 1926, London; d. of H.R.H. Prince Albert, Duke of York (later H.M. King George VI), and Duchess of York (now H.M. Queen Elizabeth the Queen Mother, q.v.); succeeded to the Throne following Her father's death, 6 Feb. 1952; married, 20 Nov. 1947, H.R.H. the Prince Philip. Duke of Edinburgh, b. 10 June 1921; children: Prince Charles Philip Arthur George, Prince of Wales (heir apparent), b. 14 Nov. 1948; Princess Anne Elizabeth Alice Louise, Mrs. Mark Phillips, b. 15 Aug. 1950; Prince Andrew Albert Christian Edward, b. 19 Feb. 1960; Prince Edward Antony Richard Louis, b. 10 March 1964. *Address:* Buckingham Palace, London; Windsor Castle, Berkshire, England; Balmoral Castle, Aberdeenshire, Scotland; Sandringham, Norfolk, England.

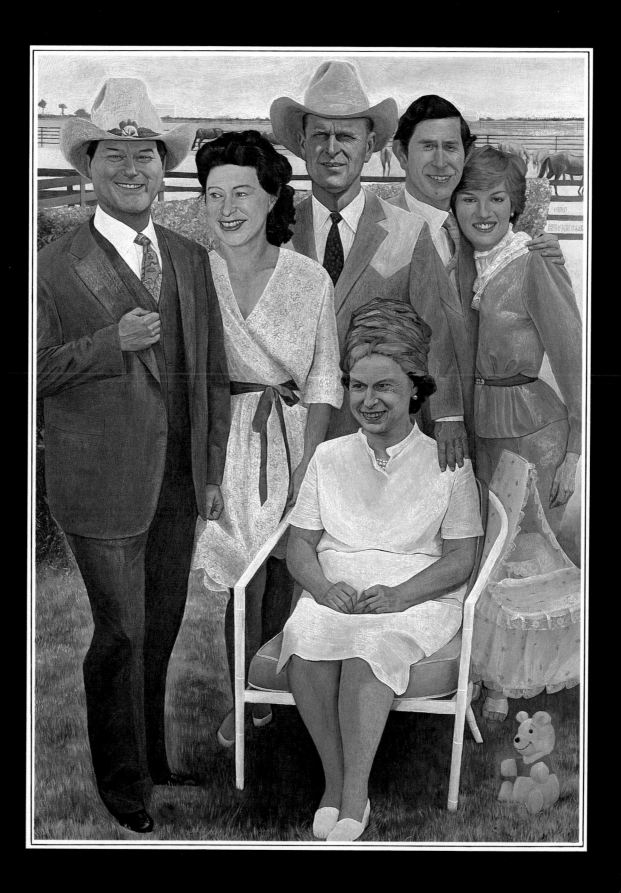

List of Paintings

The Olympics	1980 Tempera/Oil	80 x 60 cm
Mitterand/Giscard	1981 Tempera/Oil	35 x 45 cm
Ronald Reagan	1981 Tempera/Oil	50 x 70 cm
Alexander Haig	1981 Tempera/Oil	50 x 60 cm
Edward Kennedy	1979 Tempera	50 x 61 cm
Jimmy Carter and Family	1976 Tempera	60 x 76 cm
Jimmy Carter and Friends	1979 Tempera/Oil	50 x 60 cm
Pierre Trudeau	1982 Tempera	45 x 50 cm
Fidel Castro	1980 Tempera/Oil	34 x 44 cm
Leonid Brezhnev	1977 Tempera	60 x 79 cm
Lech Walesa	1982 Tempera	50 x 70 cm
Yasser Arafat	1978 Tempera	50 x 60 cm
Anwar Sadat	1977 Tempera	60 x 76 cm
Menachem Begin	1981 Tempera/Oil	45 x 50 cm
Ariel Sharon	1982 Tempera/Oil	45 x 50 cm
Moshe Dayan	1977 Tempera	60 x 76 cm
Hosni Mubarak	1982 Tempera	45 x 50 cm
Abdul Fahd	1982 Tempera/Oil	35 x 45 cm
Ayatollah Khomeini	1980 Tempera	50 x 70 cm
Mu'ammar Gaddafi	1981 Tempera/Oil	50 x 60 cm
Idi Amin	1976 Tempera	60 x 76 cm
Margaret Thatcher	1979 Tempera/Oil	50 x 60 cm
Leopoldo Galtieri	1982 Tempera	35 x 45 cm
Helmut Schmidt	1980 Oil	20 x 30 cm
Franz-Joseh Strauss	1979 Tempera	50 x 65 cm
Francois Mitterand	1981 Tempera/Oil	35 x 45 cm
Georges Marchais and les Companions	1981 Tempera/Oil	50 x 60 cm
	1981 Tempera/Oil	50 x 60 cm
Valéry Giscard d'Estaing	1980 Tempera/Oil	50 x 70 cm
John Paul II	1981 Tempera/Oil	50 x 40 cm
John Paul II and Friends	1981 Tempera/Oil	35 x 40 cm
Charles and Diana	1980 Tempera	45 x 55 cm
J.R., Margaret, Philip, Elizabeth, Charles and Diana	1982 Tempera/Oil	50 x 70 cm